Isabella Rossellini
In the Name of the Father,
the Daughter and the Holy Spirits
Remembering Roberto Rossellini

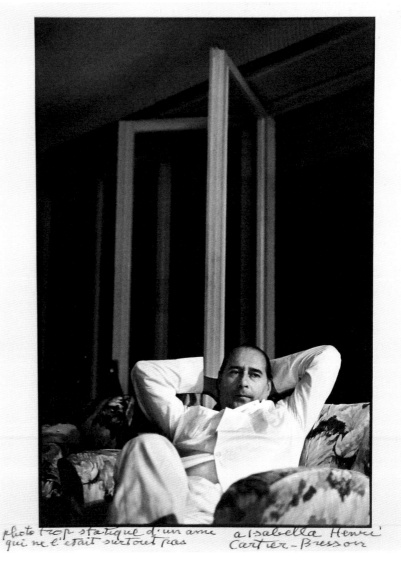

"Too static a photograph of a friend, who was anything but that. For Isabella.
Henri Cartier-Bresson."
Roberto Rossellini. Photo: Henri Cartier-Bresson

Isabella Rossellini

In the Name of the Father, the Daughter and the Holy Spirits

Remembering Roberto Rossellini

*With numerous texts, illustrations, and photographs
by Ingrid Bergman, Roberto Rossellini, Federico Fellini,
Eric Rohmer, François Truffaut, Guy Maddin,
Jody Shapiro and Isabella Rossellini*

Haus Publishing
London

For Papà

First published in Great Britain in 2006 by
Haus Publishing Limited
26 Cadogan Court
Draycott Avenue
London SW3 3BX

© Isabella Rossellini 2006
This edition published by arrangement with SchirmerGraf Verlag, Munich.
Italian texts translated into English by Guido Waldman and French texts translated into English by Nathalie Villemur.
The moral rights of the authors have been asserted.
The publishers wish to acknowledge the valuable contributions of Rainer Gansera, Munich.
A CIP catalogue record for this book is available from the British Library

ISBN 1-904950-91-4

Front jacket illustration: Ingrid Bergman (as Jeanne d'Arc)
and Roberto Rossellini, 1953 © Kobal Collection
Designed and typeset in Berthold Caslon by Huber/Pfeifer, Germering
Printed and bound by Passavia in Passau, Germany

www.hauspublishing.co.uk

Contents

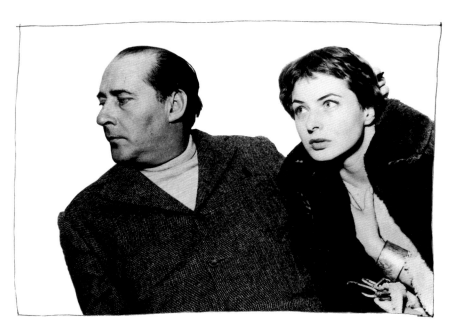

Self-portrait in the cinema, watching my parents.
(drawing by Isabella Rossellini)

About This Book

Happy birthday, Dad! On May 8th 2006 you would have been 100 years old. And this book, published the year of your centennial, is my birthday present to you. There will be other books written about you, retrospectives of your films and seminars by scholars. This book is my own, very personal voice joining the choir of people wanting to remember you.

You died on June 3rd 1977, the saddest day in my life. Remembering, however, is part of the healing process. And sharing the memories of others gives me a warm feeling - almost as warm as your lovingly protective cuddles.

This book includes not only my own memories, but also those of the "Holy Spirits", people like my mother, Ingrid Bergman or Federico Fellini, François Truffaut, and Eric Rohmer . . . friends of yours, who helped me understand you more deeply since I was still young when you died.

I wish I could have shared a bit more of my life with you. I wish you could have met my children Roberto and Elettra and have been a grandfather to them. Memories are important to me. They swim in my brain every day occuping a lot of my thoughts. I like thinking about you, Dad, it makes you present in my life although you died a long time ago.

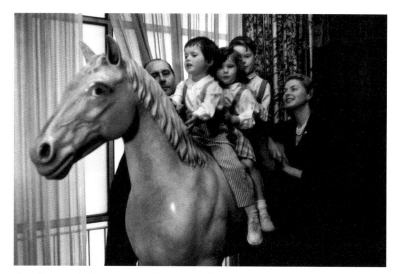

Family portrait, Rome 1956. Photo: David Seymour

Happy Birthday, Dad!
Your daughter Giggia-Sgionfabosse Isabella.

Note: Giggia-Sgionfabosse are the nick names my father
gave me. "Giggia" because my baby brother could not
pronouce my name Isabella. Sgionfabosse means "chubby
cheeks" in the Venetian dialect of my grandmother. Since
I was a chubby child, my round cheeks looked like the
cheeks of these artisans when blowing into their special
tubes to create glass sculpures and vases.

I. Isabella & Family

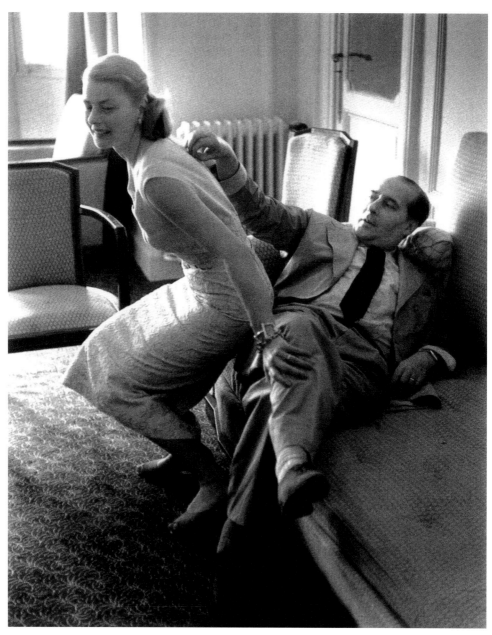

Ingrid Bergman and Roberto Rossellini 1956. Photo: David Seymour

About My Family

from *Some of Me* by Isabella Rossellini

"What is it like to be the child of famous people?" is the question I'm asked most frequently about my parents. The answer to this question is really: "I haven't been the daughter of anyone else, so I have no terms of comparison." But I know it's an unsatisfactory answer. Let me make it longer than that.

You see, my parents are "myths", and that means that everybody has a highly personal idea of who they are. Obviously it's a projection, a fantasy, but it's very vivid in people's minds. What I say about them can be different from that fantasy, and people don't like that. Of course, I can say what everyone else says, just repeat what people want to hear, which I've done, don't worry. … I have indeed, and gained a lot of sympathy and approval from it, and I enjoyed that. I do like to be liked. But truly, it is hard for me to understand the collective unconscious about Mom and Dad. In school I would always ask my classmates, "Is my mom as famous as Joan Crawford? How about compared to Greta Garbo? Is my dad as famous as Chaplin? How about compared to Hitchcock?" I needed a kind of barometer. It was hard for me to understand the degree of her fame.

My daughter has had the same problem with me that I had with my parents. For fourteen years, my photo appeared in the massive advertising campaign of Lancôme cosmetics around the world. When Elettra was born, my photo was already

there, in magazines and on TV, billboards, and posters. When she was in kindergarten, the teacher instructed the children what to do in case they got lost: look for a policeman, learn your address and phone number by heart, that kind of thing. Then she proceeded to interrogate the kids. My daughter was asked, "What would you do if you got lost in an airport?" Elettra answers, "I'd look for my mamma's poster and wait underneath it for help." She thought that ads were just photos of mothers that were plastered around airports, streets, freeways, in case kids got lost and needed help.

My nephew Alessandro suffered from the same kind of problem. He had a teddy bear he believed was a male, his son, and he named him "Ingrid Bergman". Alessandro kept hearing this name pronounced with some kind of mystic aura, which he never connected with the person he called "Grandma".

With Elettra. Photo: Oberto Gili

I named my daughter "Elettra Ingrid" because I loved my mom and dad. Elettra is the name of my father's mother, the only grandparent I knew, since the others were dead when I was born.

"How could you call your daughter Elettra? It's the opposite of the Oedipus complex, it's about penis envy. The Elettra complex is exaggerated love for the father, tied to hating the mother. In the Greek drama, Elettra goads her brother, Orestes, to kill their mother, Clytemnestra, because Clytemnestra and her lover had killed their father, Agamemnon."

Well, I didn't know all that, but guess what … it's an incredible coincidence, or, if you prefer, one of those Freudian things where your unconscious knows better than you do. I had the Elettra complex, I may still have it. I loved my dad

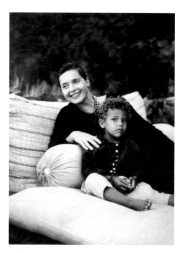

With Roberto. Photo: Fabrizio Ferri

exaggeratedly. I never wanted to kill my mother, I loved her, but as a child I was definitely my dad's girl.

When I had my son, I called him "Roberto" and gave him the middle name "Robin" for my love of animals and because I don't want anyone to nickname him or call him anything that won't at least sound like my dad's name.

"Poor child, he should have his own name. Roberto Rossellini! It's like being called 'Alfred Hitchcock' or 'Greta Garbo.' He will always feel the weight of this name, and people will make fun of him."

People! What will they say? What can they do? "Fuck them," recommends my friend Gary Oldman, the actor and director. "Who are 'they', anyway?" Gary follows the question with a little pause, as if waiting for me to answer. But inevitably he feeds me the answer he hopes will cure my ever-present impulse to please, which he considers deplorable. "Fuck them. Remember, this is the shortest prayer in the world: Fuck them!"

I was familiar with "Fuck it" from years ago, when I was married to Martin Scorsese. He would wake up saying it over and over in fast succession. "What's the matter with you?" I would ask. "The day hasn't yet started, nothing's gone wrong, so why start cursing?" But it wasn't cursing. I understood that later, when I acquired a little more wisdom. "Fuck it" was a necessary pronouncement, like a mantra. It helped Martin gather energy to get out of bed and face a new day.

With a "Fuck them" and a "Fuck it", I gave my children family names. If I hadn't, I would have succumbed to my parents' fame instead of to my love for them. It would have been like giving fame control over my choices, and I don't want that. To

me, my dad is my dad, first and above all, and my mother is my mother.

Tradition calls for children to have their grandparents' names, especially the ones who are dead. It's all that is left of them - memory. And neither of my children knew my parents; all they'll have is what you people have: the *Casablancas*, the *Open Citys*, the *Notoriouses*, the scholarly books on their work and the unauthorized biographies, the occasional photo in magazines for special editions such as "The Hollywood Legends," and, because of the big scandal their love provoked in the fifties, in the collections of "The Biggest Loves of the Century" with Liz Taylor and Richard Burton, Wallis Simpson and Edward VIII, and the prince and princess of Wales.

My children also get glimpses of my mom in television promotions for film programs. She makes it into almost all of them: TNT, American Movie Classics, the Independent Channel. At home when we hear the jingle for movies (we recognize it because it always has that soaring, heartbreaking music), we stop and check if she's in it. Most of the time she is. When she isn't, I grimace at the TV set as if to say, "Your loss". My children do the same, especially now that they've learned to recognize their grandmother. You know, in black and white with those hairdos and that dramatic lighting, all stars can look a bit the same.

Both my parents are in just about every encyclopaedia. I check, you know. When my father's entry emphasizes his marriage to my mother, I know it's an American edition. When the emphasis is on his revolutionary and innovative work as a film-maker, I know it's a European edition. In Chinese encyclopaedias my mother isn't mentioned at all and

my father's work is described as "nonbourgeois telling true stories about the proletariat". That's the Communist edition. There are many ways to love my parents. Then there is my way, which is mine only.

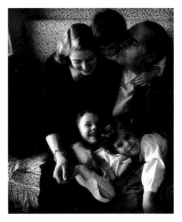

My parents, my brother Roberto, my twin sister Ingrid and I, 1956.
Photo: David Seymour

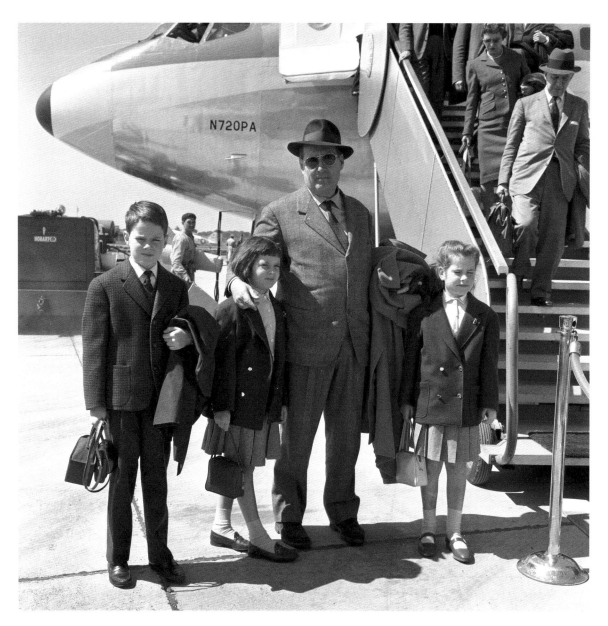

Travelling with Dad, 1960. Photo: Pierluigi Praturlon

About My Dad

from *Some of Me* by Isabella Rossellini

My father was a Jewish mother. But let me add something about him that I can say only now that he's dead. He was fat. In my family, this fact was always diplomatically diminished with, "He's not fat, he's robust."

When we were children (there were seven of us), one of our favorite games was throwing ourselves onto Daddy's body. Lying on his side, he pretended to be the sow and we were the piglets. My dad always regretted not being able to nurse us in real life, though for a long time I believed he was pregnant. I arrived at this conviction because I misunderstood my baby-sitter's confusing explanations of childbirth and because of the scandalous articles about my family in tabloid newspapers. The tabloids talked about my parents' divorce and of a mysterious, exotic woman (only later on did I realize they were just talking about my stepmother, Sonali, who is considered exotic, I guess, because she comes from Calcutta) and of "extramatrimonial" children. This word, "extramatrimonial", was just like "extraterrestrial", and I gathered that this was maybe what we were and why we deserved so much attention from the press.

"Extramatrimonial" also made me think of supernatural phenomena, and my father had this big belly, just like a woman nine months pregnant. I liked him just as he was, fat

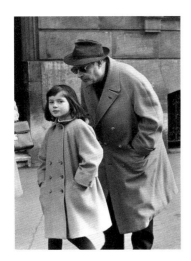

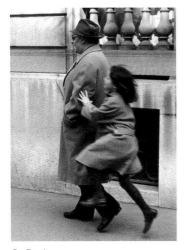

In Paris, c 1959.
Photos: Federico Garolla

or robust, whatever one wants to call it. People who talked to him about dieting irritated me – I didn't want less of him. He was soft to embrace, and there was a lot of him. I wanted him a lot, and I wanted all of him.

One of Dad's biggest passions was driving – in his youth he had been a racer for Ferrari. Often, he would load us all up in his car and drive through Italy's little villages and cities. He would drive fast, pressing the horn, klaxoning all the way, whistling Neapolitan songs and telling us fantastic stories that inflamed my imagination. I remember his hands, covered with liver spots, gripping the wheel like a champion car racer, tightly and strongly. I thought his hands were beautiful. Years later, when I saw a few liver spots appearing on my own hands, I went proudly to show them to an art director – something else to photograph, I thought. He was horrified.

At Sunday lunch, when the family was united around the table, my brother Gil would play the sound of racing-car engines he had taped at Maranello, the Ferrari headquarters he frequently visited. My father loved to hear all that noise. I did not. To show the depth of my disgust, I didn't rush to get my driver's license at eighteen. Missing it then, I missed it forever. I still don't know how to drive.

It was my brother Roberto who, slapping my father in the face, convinced him to give up racing cars – he was only three years old when he took this matter into his hands. He had witnessed my mom's agony at waiting for Dad to come home safely.

But most of all, I remember my dad in bed – he loved being in bed. He stayed in bed all day long; he didn't want to waste energy. You can call him lazy, but I still connect physical laziness to the kind of spiritual and intellectual wisdom my father

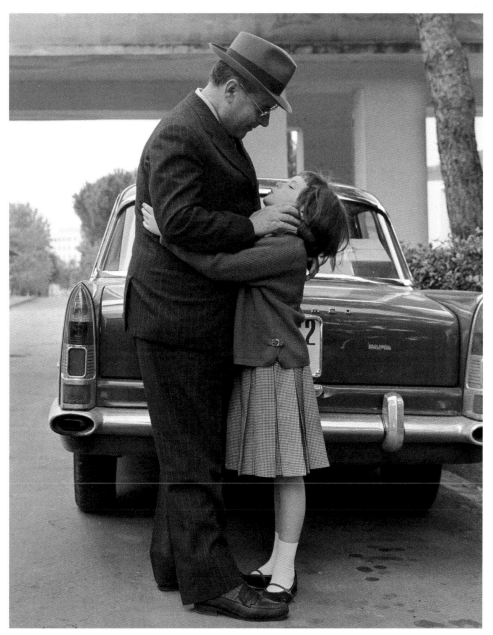

Roberto Rossellini with Isabella, 1960. Photo: Pierluigi Praturlon

possessed. If someone strikes me as lazy, my first reaction is to listen carefully to what he says for some possible great truth. As an adult, I like a "lazy body" look in bed. An athletic body with muscles I could never love. In bed my dad kept books, magazines, newspapers of all kinds. He read a lot and talked on the phone. He had meetings with collaborators, students and producers, all from his bed. Even his film-editing table was placed next to his bed.

The entire family worked on father's set. My brother Renzo (right side in the background) was first assistant and producer, father's first wife was the costume designer, I helped her. My cousin Geppy was set designer, my uncle Renzo wrote the music, my aunt Marcella helped write the script and did continuity (on the set of Blaise Pascal, *1971).*

II. "My Dad Is 100 Years Old"
A Film Tribute

Why I Made This Movie

I asked the Canadian film-maker, Guy Maddin, to direct *My Dad is 100 Years Old* because I wanted to borrow his unique use of images – full of what I like to call, "movie-nostalgia" – for my film. Being involved in cinema archives and film preservation, I've seen films that exist in terrible states: damaged, scratched, with missing frames. It is a sad sight that inevitably fills me with a longing nostalgia and a burning desire to hold on to these ghosts of our past.

Guy's films are purposely photographed in a ghostly fading fashion and while watching his films I experience the same anxious feeling I have in the film archives. I have an ever present fear that the film may disintegrate right in front of my eyes and I would have the last sight of those actors' faces, emotions, stories . . .

Borrowing Guy's images, I wanted to convey what I experience when watching my Dad's films fading away. My father is slowly being forgotten. For me it's like a water torture, drip . . . drip . . . drip . . . into oblivion.

The seriousness of my family, the dramatic expression of their great films, has left me comfortable only with one voice: humor. Humor has always been my weapon. I've used it since I was a child to duck authority and get my way.

In the film I play all the roles, David O. Selznick, Alfred Hitchcock, Federico Fellini, Charlie Chaplin and my mother Ingrid Bergman. This was Guy's idea – he told me this would be the best way to show the audience that these are my memories, the way I recollect the debates I heard as a child about cinema. My Dad is represented just as a big belly – the big belly he envied pregnant women, the big belly I've embraced so many times and where I took my best naps cuddling against it as a cushion.

My 17-minute film is my humble, humorous, antidote; my paddling against the current of time. I don't expect it will do much against the inexorability of "time marching on"; I know I ultimately have to accept the impermanence of our life ... the impermanence of it all. So be it, but not without a fight.

Movie Making with Isabella
By Guy Maddin

What a simple pleasure it is to bring Isabella's picture out this year, but what a macabre and delicious thrill it was for me in the months leading up to this moment to collaborate with her on this singular filial reminiscence. In the name of research, I got to grill her about her childhood and all the immortals that occupied it at one time or another; in a series of interviews with her, I keenly mined her for priceless anecdotal gems, and dug even more avidly for the dirt, from her rich and strange life, a biography that stretches far back to times which even predate her scandalous birth, into the glorious film histories of two continents, and which she laid before me, her trusted director, to use as I wished. And purely for the sake of my own nosiness, I made personal, and titillating, researches, completely irrelevant for this project, into her most intimate friendships in the fashion and movie industries; I made a phrenological study of her skull; and during one extended stay at her home she let me sleep in her mother Ingrid's deathbed. As a storyteller, she is sometimes an awestruck little girl, sometimes a regal serenity, sometimes a bawdy beauty with a hair-trigger laugh and a taste for the grand guignol. She's always frank and practical, vulnerable and perceptive, refreshingly morbid and

always surprising. I felt my only job as director was to get this complicated recipe that is Isabella onto the screen without forgetting any essential ingredient, freeing her to tell you her tribute in her own wonderful way.

My Dad Is 100 Years Old

Script and illustrations by Isabella Rossellini

ISABELLA *(voice-over)*

My father said . . .

ROBERTO *(in voice-over as performed by Isabella)*

. . . The technological discoveries of the 20th century are as big as the discovery of fire for the primitive man.

ISABELLA

My father said: "I AM A JEWISH MOTHER!" He told me he always regretted not being able to nurse us, his seven children. Our favorite game was throwing ourselves on Daddy's body – lying on his side he pretended to be the sow and we the piglets. I would embrace his enormous belly; soft, round, big, warm, cuddly.

ISABELLA *(continues in voice-over)*

I liked my dad fat. People who talked to him about losing weight irritated me. I didn't want less of him there was so much to embrace. I wanted all of him!

My dad stayed mostly in bed. He stay in bed all day long. He didn't want to waste energy. He saved it all to think.

On his bed . . . he read . . . he wrote . . . met his collaborators, . . . smoked . . . drank espresso . . . spoke on the telephone . . . edited his films.

If my Dad was an animal he would have been a seahorse. It's the male who gets pregnant. It's the male who takes care of the babies.

Most of all, my father thought and thought and thought. He ate glucose pills to nourish his brain.

He kept an ice bag on his head to keep down the heat his brain produced by so much thinking. In spite of this he occasionally got humongous migraines.

Occasionally he admitted himself to a clinic to intravenously get some heftier nourishment for his brain.

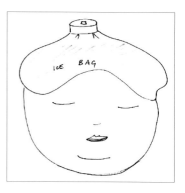

My father was a genius ... I think ... but for some he was a fool, a loser, a pain in the ass. They said his films were boring, commercially unsuccessful, and he was stubborn in his ways.

For years I tried to reconcile the difference of opinions.

Were his films too poorly made, unprofessional, or truly sublime in their starkness and simplicity?

My friends preferred Hollywood movies!

———————

My father once announced: "Cinema is dead!"
A headline swiftly rebutted: "Rossellini's cinema is dead!"
Lots of laughs about that one. I felt bad. I always felt like
protecting my father.

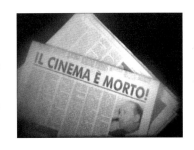

Now that my father is 100 years old, the questions, the
doubts have given in to tenderness.
Infinite tenderness.
My father used to say important things:

ROBERTO *(as performed by Isabella)*
Before film, access to knowledge and culture was limited
mostly to those who could read. Films make culture im-
mediately accessible to anyone.
FILMS WILL DEFEAT IGNORANCE IN THE
WORLD!!!

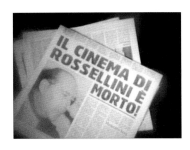

――――――――――

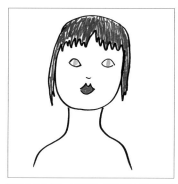

ISABELLA *(voice-over, in a complete whisper)*

… He took frequent naps. Short, little, cat naps. They were necessary pauses for his active brain to regenerate – just like a weight lifter needs to take rests in between sets …

———————————

ISABELLA

My father was a teacher, both behind the camera and at home. More than once he said:

ISABELLA *(switching to Roberto's voice)*

Suppose you read the description of an animal you had never seen. You would be told it has a long nose …

ISABELLA *(voice-over)*

And I would imagine all long noses I have seen.

ROBERTO *(as performed by Isabella)*

A long nose that looks like a hose …

A skin that is wrinkly and gray …

Tall as two horses, maybe three, on top of one another.

ISABELLA *(voice-over)*

Reading descriptions is not precise. They can lead to a lot of misunderstandings, approximations, mis-information.

But if you can see a photo of an elephant … and then as film technology progressed you can capture the elephant's movements, the elephant's sounds … the elephant's colours.

In a glimpse you will have an accurate totally informed and precise idea of what is an elephant.

ROBERTO *(as performed in voice-over by Isabella)*

My films don't interpret anything. I don't want to interpret an elephant. I want to show it as it is. Reality is much

stronger, more extraordinary than anything our human mind can produce. I don't want to be called an artist because I don't want to be confused with that bunch of narcissists who think their creativity, their interpretations of the world, their original points of view, are the only things that count!

(now with anger)

Most of the time you know where their point of view, their inspirations come from?

HERE!

(Roberto grabs his genitals)

VOICES *(all performed by Isabella)*

 – Come on, Roberto …
 – Artists, of course we are artists!
 – Go to hell, Roberto!
 – What a ball breaker!
 – That Rossellini makes films look so shabby. He is lazy!
 – There's nothing spectacular in his films. He wants to charge us for things we can see with our own eyes in the street.

DAVID O. SELZNICK *(as performed by Isabella)*

 Film is art! It comes from story telling … theater, literature! The best films in fact have a strong narrative. Films should illustrate novels.

 That's the best entertainment – like my "Gone with the Wind."

FELLINI *(as performed by Isabella)*

 Novels … theatre … literature … what about dreams, huh?

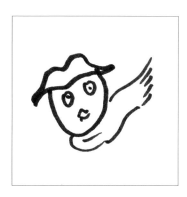

FAMOUS
HitcHcock
pROFILE

My films are about dreams … it's what I achieved with "8 1/2".

ROBERTO (*as performed by Isabella*)

You Federico, we were best friends and you betrayed me. We worked together and then you let your dreams derail you. And what dreams??? Tell me! Wet dreams??

HITCHCOCK (*as performed by Isabella*)

It's all about how you tell a story. That's where the artistry of a director lies. I want to grab my audience, manipulate my audience. While sitting there in the theatre I want to make their hearts race! Just like my heart raced when I was a baby and my mother played "peek-a-boos" with me.

CHAPLIN (*as performed by Isabella*)

You have to tell a story with humor, especially a sad story otherwise the audience will not listen. A little smile, a little tear and they'll follow you a long way.

ROBERTO (*to Chaplin*)

Chaplin, you are different from the other filmmakers. On my desk I kept your photo. You are the real maestro. Weren't your films talking to the highest essence of man, our consciences, our souls … whatever you want to call it? That thing that makes men different from animals! Their films talk to the animal in us. Sex, fear, survival … that doesn't define men.

The definition of man lies in our conscience!

HITCHCOCK (*as performed by Isabella*)

You should have been a priest Roberto, not a filmmaker.

ROBERTO (*as performed by Isabella*)

You should have been a magician Hitch. Your films may be fun to watch, but there is nothing noble about them – indeed they are all about the peek-a-boos manipulating

peoples' feelings. It's like masturbating instead of the real thing: making love!

SELZNICK *(as performed by Isabella)*

Oy, oy, Roberto. You are so Italian, so MELODRA-MATIC, so opera-like.

It's all a bit simpler than that. Audiences want to be distracted … to have a bit of fun after a long day at work.

People watch films to relax and to be entertained…

ROBERTO

David, you know better than to call a film just ENTER-TAINMENT! When you died, I got a phone call from Shirley Temple telling me about the silver cigarette case you left me with the inscription:

TO ROBERTO:

WHO CONTRIBUTED GREATLY TO FILMS

Why did you do that?

SELZNICK

You brought to films a realism that was unprecedented. Your films look so real, so authentic, they looked like documentaries.

ROBERTO

I hate the reduction of my films to style. Neo-realism they were labeled. My films were more subversive than just mere style. My ultimate goal was to address our conscience, your Hollywood films would flee away from it by distracting, diverting, entertaining …

HITCHCOCK

Our Hollywood films are well done. Your films are slow, slack, poorly made.

SELZNICK

I have to defend Roberto here. I know you directors …

FAMOUS Hitchcock profile

you want to control films. The more the film costs the more you will have to respond to the commercial laws. Roberto keeps his films poor to preserve his freedom to control.

ROBERTO

I always liked you David, because you understood me – even if you never produced me. We were incompatible.

FELLINI

My films address our conscience too. Actually, they address our unconscious. When I say my films are dreams I mean that ever-present aspect of our life that is yet so intangible.

ROBERTO

The ability that our brain has to imagine is there to help us go further, to help our intuition. My films don't come from pure imagination nor pure reality.

My films are between reality and fiction. I don't know why my films were called NEOREALISM. They are probable. A proper definition would have been PROBABLE FILMS.

I study and reconstruct events in order to understand human behavior. For example, in 1939 I read in the newspaper that a woman who lived in a low income apartment in a neighborhood in Rome was shot. I went there and asked how it happened. My film "Open City" portrays how the events PROBABLY occurred.

———

(Ingrid Bergman appears on the screen)

INGRID BERGMAN

I fell in love with Roberto even before I'd met him, just watching his "Open City". I wrote to him . . . I wanted to work with him. We ended up doing more than that. Five films and three children.

ISABELLA

MAMA!

INGRID BERGMAN

It wasn't easy working with your father. He didn't use professional actors. No one knew when to talk.

ISABELLA

Father used professional actors. What about the great Anna Magnani?

INGRID BERGMAN

She was different from me and extraordinary. "La Lupa", she was was called, like the symbol of Rome, the she-wolf who nursed Romulus und Remus, the founders of the city. La Lupa, the wolf. Anna was a wolf.
(we hear howling and see a shadow of a wolf)
I couldn't do what she did. She improvised, provoked reaction from the non-actors, she was bold. I am shy.

ISABELLA

Was Anna hurt when Father left her for you?

INGRID BERGMAN

Ja, very.

ISABELLA

Some say, Father destroyed your career.

INGRID BERGMAN

No, I destroyed his.

ISABELLA

Why did you fall in love with Dad?

INGRID BERGMAN

Because Roberto was so rare. No one was like him. Free, generous … even with money he didn't have, and strong. He gave me courage – something I never had.

ISABELLA

Why did you divorce?

INGRID BERGMAN

Roberto was always in turmoil. He needed a hurricane. Life was a battle . . . films were a battle . . . If there weren't battles to fight he was bored. After a while I couldn't take it any longer. I needed some calm.

(The wolf devours Ingrid. Screen goes black)

ISABELLA

I met Anna occasionally with my dad. I never really took a good look at her. I always kept my eyes lowered throughout these visits and never said a word to her. I knew she hated my mom and worried that she would hate me too. With my eyes lowered I saw nothing of Anna but her feet. She wore pink satin slippers with a little heel and decorated with some down feathers, very feminine and out of character, I thought. I had seen her in her films as a strong, foul-mouthed character, ready to curse, slapping men right and left.

Many pets roamed around her feet. They were mostly cats. Some seemed the result of too heavy interbreeding that was probably taking place right there in the confines of the apartment.

I don't remember any gossip or any negative comment about Anna. My family referred to her only as a great actress.

(*Isabella interrupts herself*)
 Why is the camera up there?

ISABELLA (*continues with frustration*)
 Come on, stop that!
 Please stop these . . . these "immoral" camera moves, as my father would have called them. Showoffy, uncalled for, just put there to either distract from what I am saying, or bamboozle the audience in case I have nothing to say. But I have something to say! Just stay put, still, at eye-level – just as Rossellini would have done it!

ISABELLA (*to camera that is assuming the correct position*)
 My father said the most direct way is the simplest. That's why his films were so pure.

(*Isabella continues Anna's story*)
 Anna died before my dad and mom. She died in my dad's arms. By the end of their lives they found each other again, not as lovers, just as great, great, friends.

If I had to divide my own life, the way history is divided into BC and AD, I would choose as a dividing line, June 3, 1977, the day my father died.

My Mom described Dad's death by heart attack as "Fast, just as he drove his Ferrari".

In the last few years of his life he decided to make films about science. He spent many months every year in Houston to be near NASA where he worked with scientists.

I did help him with his science films. He sent me to the Mediterranean Sea to fish for urchins.

The black ones were the males. The ones with green, blue, or purple were females.

In the kitchen we would open them up take their eggs and sperms and mix them in a dish and put them under a microscope. This is what we saw:

A big, fat, immobile egg surrounded by dozens of frantic swimming sperms attacking it.

As soon as one sperm penetrated the egg it dissolved into it. The indication that its entrance had in effect was immediate; a ring appeared around the egg like a tougher impenetrable layer.

And then …

the egg and sperm divided into two …

the two into four …

the four into eight …

At this point everything stops but I was told each part would have kept dividing and specializing, becoming the urchin's spikes, the beak, the flesh we eat, etc. So it would be for man. Legs … eyes … brain. But in contact with the open kitchen air, everything died quickly.

ROBERTO (*as performed in voice-over by Isabella*)

Many people believe that man is motivated by two impulses: Fear and Desire. Films deal with that, horror films, murder stories, sex appeal, glamour, action. I would add to fear and desire, knowledge. That is what my films are about … KNOWLEDGE.

This is my definition of man: It is an erect creature who wants to stand on his toes to look further out in the horizon.

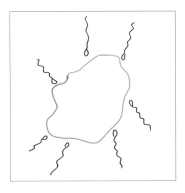

ISABELLA

Dad, if all you said makes so much sense, why didn't over 100 years of cinema defeat ignorance in the world? Why is that your films are not seen? Why is it that you are slowly being forgotten? I don't even think people understood your films.Were they too original or you did you not execute them clearly? Who knows?

You still have a hardcore group of fans who believe you'll be rediscovered … like "Van Gogh" was. You called them "The Rossellinians" and you dismissed them by often telling me: "There is nothing worse than a Rossellinian!"

After you died I had two children. I called my daughter Elettra after your mother. Then I found out that it was also the name of a complex: The Elettra complex – a daughter

adoring her father too much. I am afflicted by that com
plex. I have a son and I called him like you: ROBERTO.

I love thinking of you, thinking of your passion, your crazi
ness. You were so right about film ...
But so what??

I love you, Dad.

THE END

Film Credits

The DOCUMENTARY CHANNEL
presents

My Dad Is 100 Years Old

Written by ISABELLA ROSSELLINI

Directed by GUY MADDIN

Produced by JODY SHAPIRO

Co Producer PHYLLIS LAING
Executive Producer NIV FICHMAN
Commissioning Editor for The Documentary Channel
 MICHAEL BURNS

Featuring ISAAC PAZ SR.
 as the belly of Roberto Rossellini

Editor JOHN GURDEBEKE
Music CHRISTOPHER DEDRICK
Director of Photography LEN PETERSON
Lighting Supervisor MICHAEL DRABOT
Production Designer REJEAN LABRIE
Make Up DOUG MORROW
Costume Designer MEG MCMILLAN
Wigs provided by SERGE NORMAND
Sound RUSS DYCK
Sound Editors DAVID ROSE DAVID MCCALLUM
 JANE TATTERSALL RONAYNE HIGGINSON
Re-Recording Mixer LOU SOLAKOFSKI
Production Manager ANASTASIA GERAS
1st Assistant Director RICHARD O'BRIEN-MORAN

A DOCUMENTARY CHANNEL Original Production
Produced in association with SUNDANCE CHANNEL

The Film Poster

The Film in Pictures - In Front and Behind the Camera
Photographs by Jody Shapiro

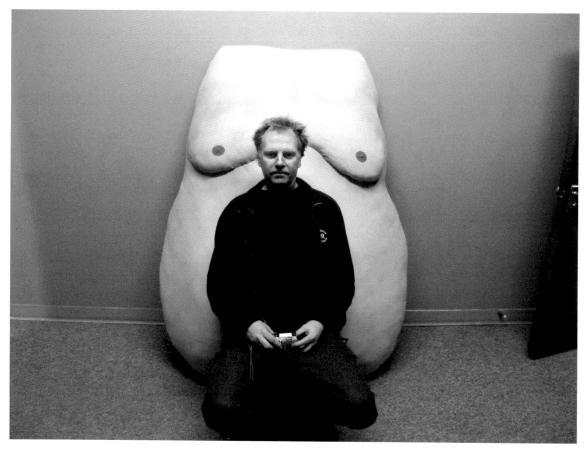

Guy Maddin, the director, posing with my "Father's Belly".

Me on the set, preparing for my masquerade.

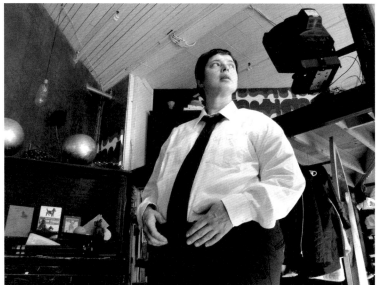

Becoming Hitchcock.

Being Hitchcock.

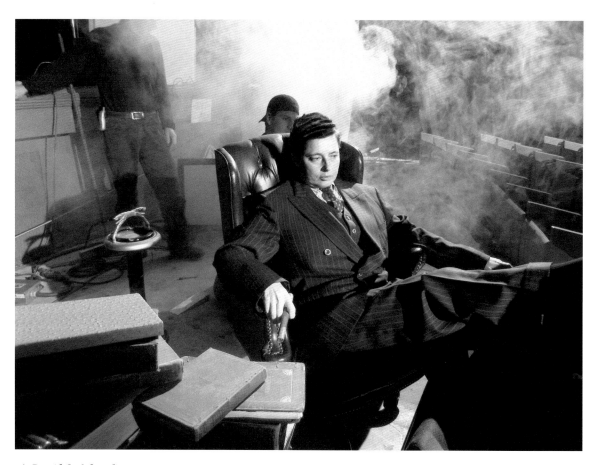

As David O. Selznick…

… and Federico Fellini.

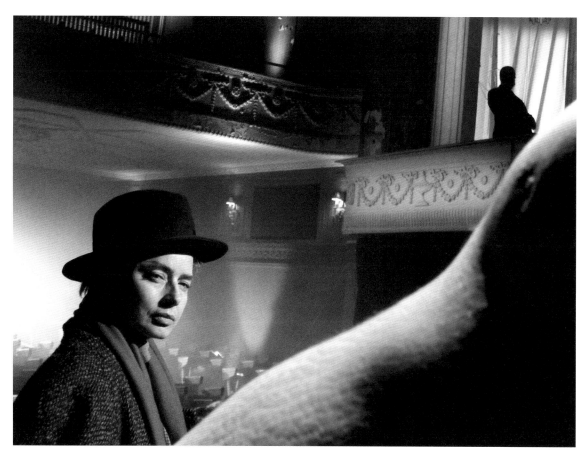

Federico Fellini, Alfred Hitchcock and the Belly.

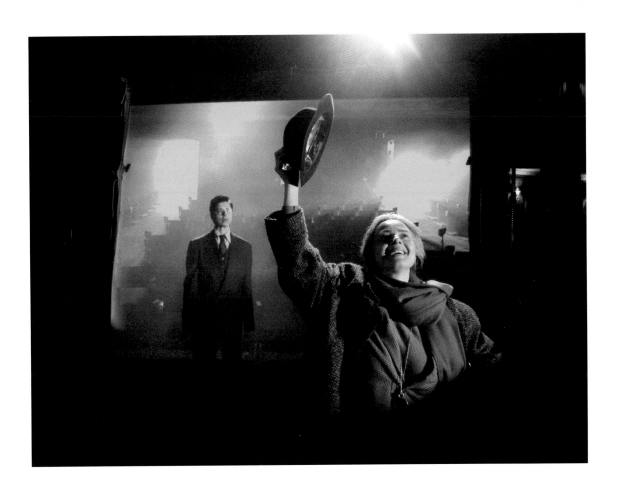

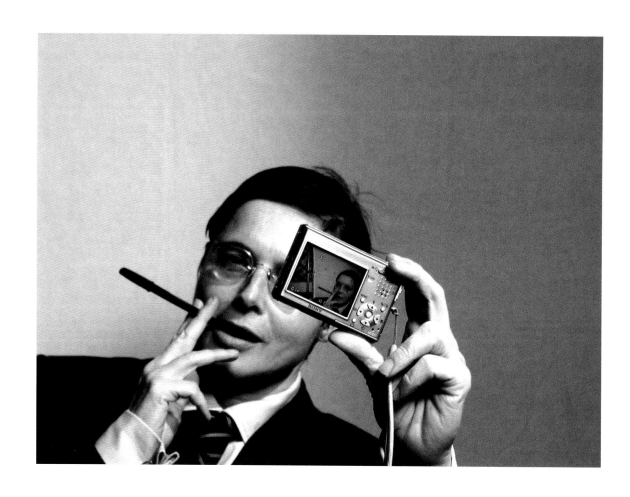

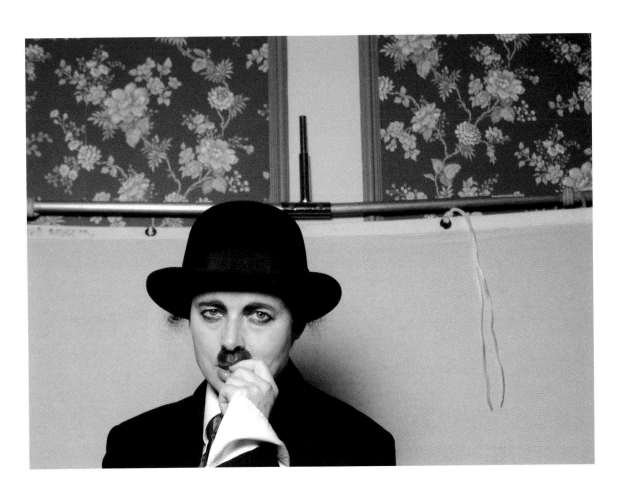

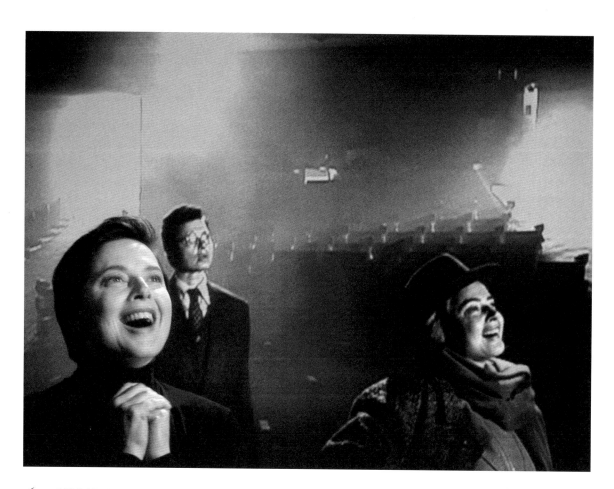

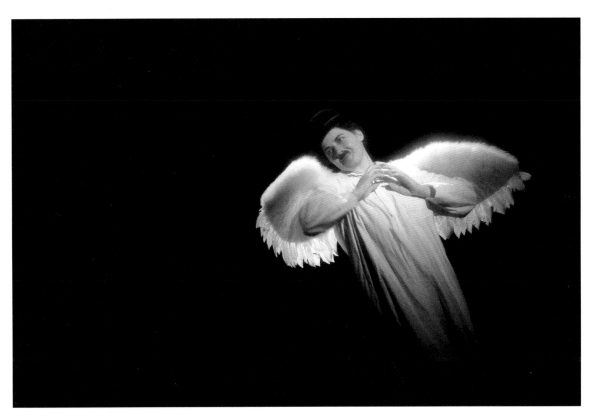

Roberto, life is a tragedy
when seen in close-up,
but a comedy in long shot.

Charlie Chaplin to Roberto Rossellini.

Becoming Mama

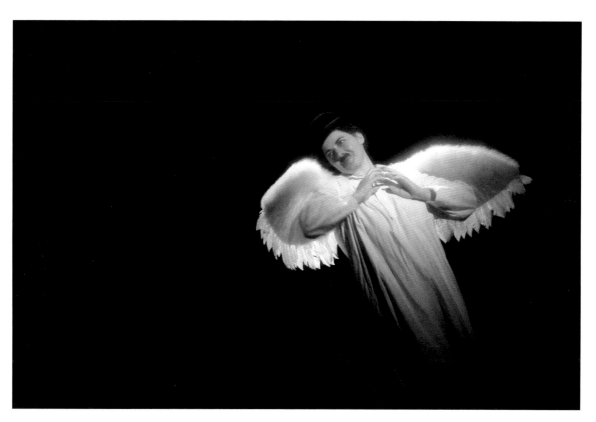

Roberto, life is a tragedy
when seen in close-up,
but a comedy in long shot.

Charlie Chaplin to Roberto Rossellini.

Becoming Mama

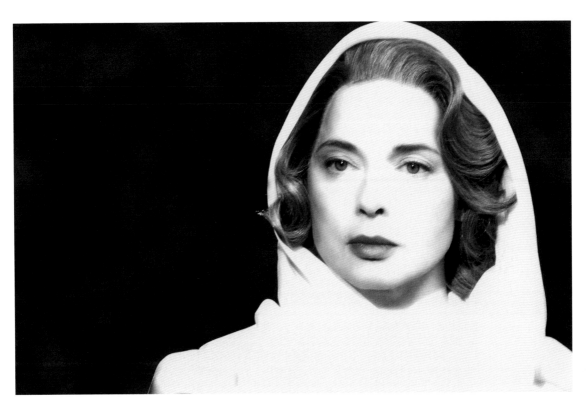

Me as my mother.

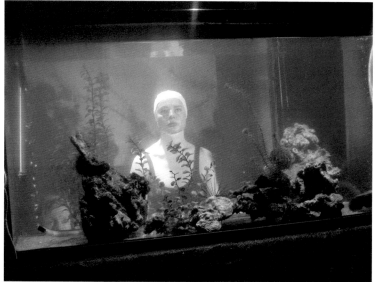

Marine images of the family.

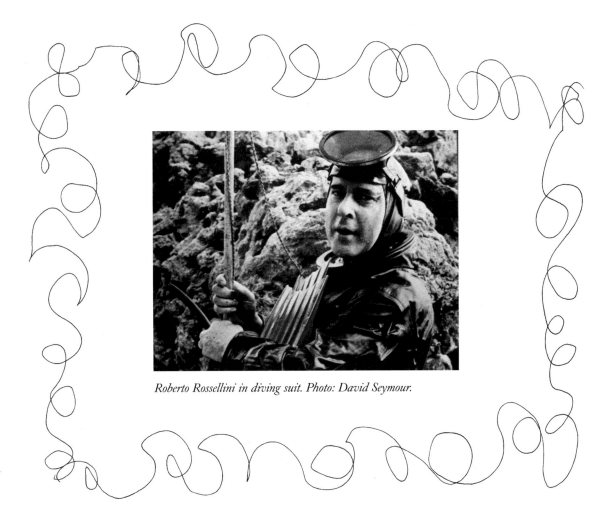

Roberto Rossellini in diving suit. Photo: David Seymour.

My dad's belly - soft, round, buddha-like.

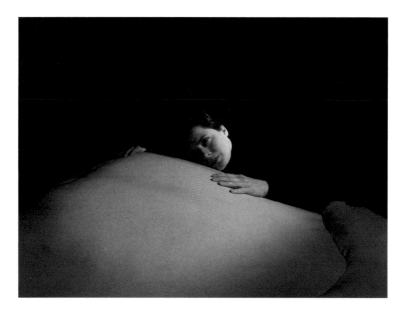

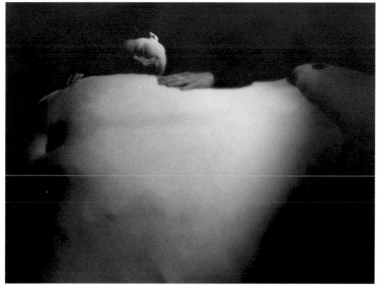

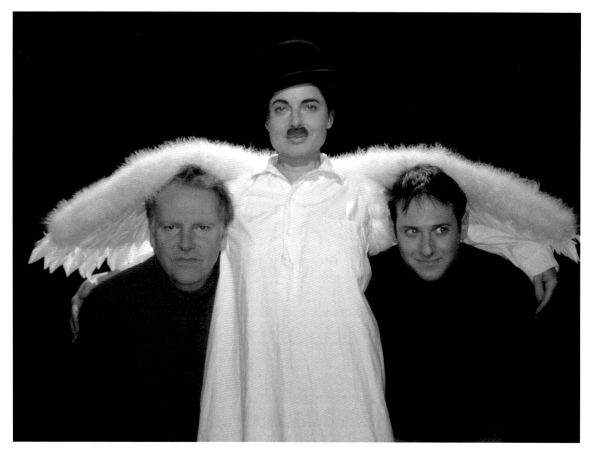

My Guardian Angels: Guy Maddin (left) and Jody Shapiro.

The film crew.

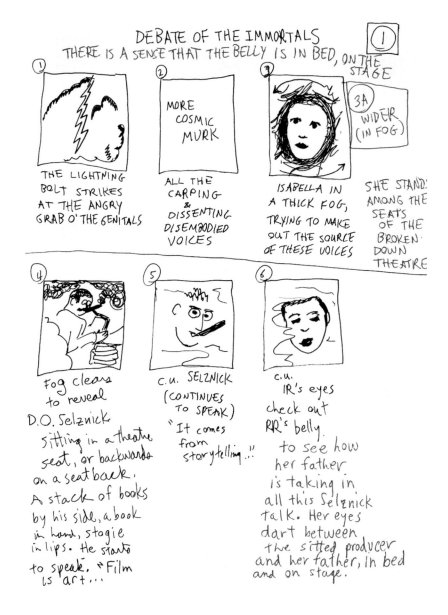

From Guy Maddin's storyboard

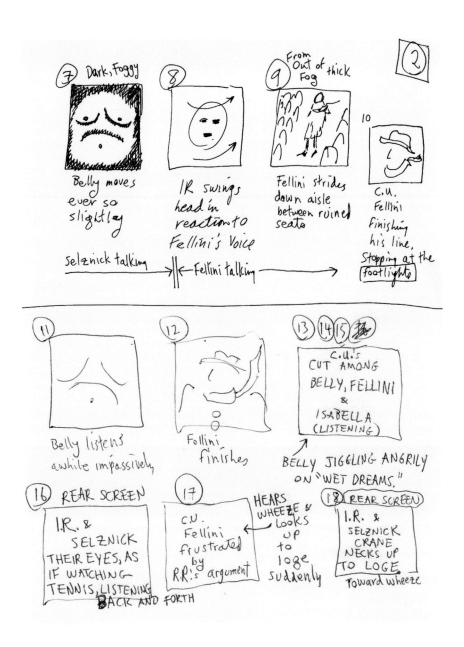

⑦ Dark, Foggy

Belly moves ever so slightly

Selznick talking →||← Fellini talking →

⑧

IR swings head in reaction to Fellini's Voice

⑨ From Out of thick Fog

Fellini strides down aisle between ruined seats

2

10

C.U. Fellini finishing his line, Stopping at the footlights

⑪

Belly listens awhile impassively

⑫

Fellini finishes

⑬ ⑭ ⑮ 🔟

C.U.s CUT AMONG BELLY, FELLINI & ISABELLA (LISTENING)

BELLY JIGGLING ANGRILY ON "WET DREAMS."

⑯ REAR SCREEN

I.R. & SELZNICK THEIR EYES, AS IF WATCHING TENNIS, LISTENING BACK AND FORTH

⑰

C.U. Fellini frustrated by R.R.'s argument

HEARS WHEEZE & looks up to loge suddenly

⑱ REAR SCREEN

I.R. & SELZNICK CRANE NECKS UP TO LOGE

Toward wheeze

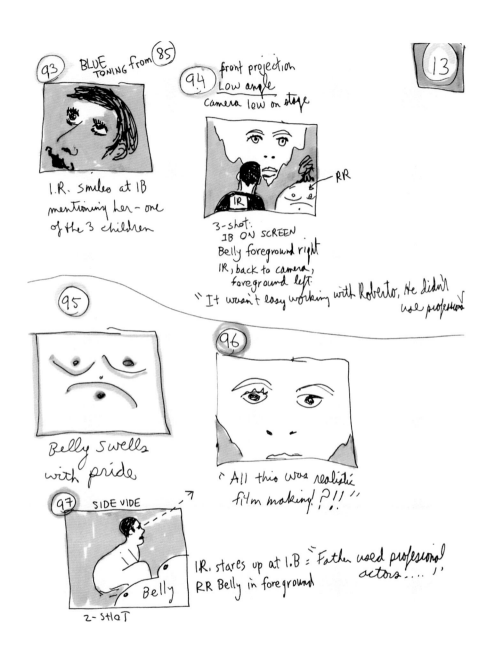

93 BLUE TONING from 85

I.R. smiles at IB mentioning her – one of the 3 children

94 front projection LOW angle camera low on stage

RR
IR

3-shot:
IB ON SCREEN
Belly foreground right
IR, back to camera,
foreground left
" It wasn't easy working with Roberto, He didn't use professional"

95

Belly swells with pride

96

" All this was realistic film making! ? !! "

97 SIDE VIDE
Belly

IR. stares up at I.B = "Father used professional actors"
RR Belly in foreground

2-SHOT

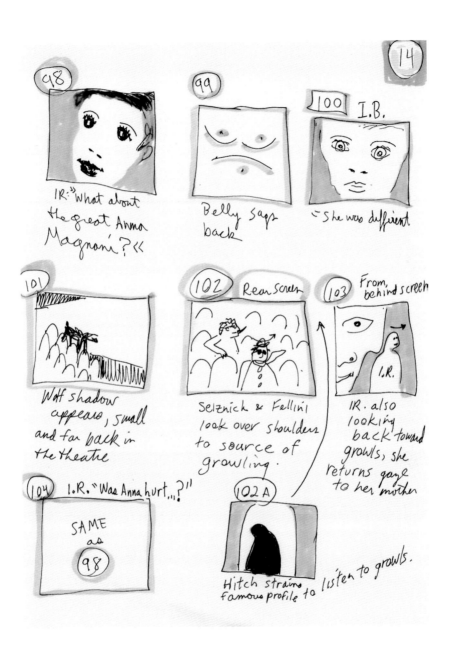

98 IR: "What about the great Anna Magnani?"«

99 Belly sags back

100 I.B. "She was different"

101 Wolf shadow appears, small and far back in the theatre

102 Rear screen Selznick & Fellini look over shoulders to source of growling.

103 From behind screen I.R. IR. also looking back toward growls, she returns gaze to her mother

104 I.R. "Was Anna hurt...?" SAME as 98

102A Hitch strains famous profile to listen to growls.

III. Ingrid & Roberto

A Note by Isabella

A great scandal hit my parents' lives with the strength of a tsunami in 1949. My mother Ingrid Bergman who came originally from Sweden, was by then one of the most celebrated Hollywood actresses with successes such as *Dr Jekyll and Mr Hyde* by Victor Fleming, *Casablanca* by Michael Curtiz, *For Whom The Bell Tolls* by Sam Wood, *Gaslight* by George Cukor, and *Spellbound* and *Notorious* by Alfred Hitchcock.

My Father by then had just had an international success with films like *Open City* and *Paisan* - The power of my father's films lay in the fact that they looked completely different from any other films. With the use of "authentic faces" that were non-actors playing principal roles and every scene shot not in studios but on locations. Dad's films looked like reality. His innovative style was in fact labeled "Neo-realism" by film critics and scholars and his work recognized as one of the most powerful and influential in film history.

My mother contacted my dad to work with him (correspondence in the next page). While working together they fell in love and Mom became pregnant with my Dad's child (my brother Roberto who is two years older than I). My Mom was married to Peter Lindstrom and had with him a little daughter, Pia. The scandal that broke out was unprecedented and reported in the front pages of all the newspapers. Dad and Mom became for years the victims of press gossip and paparazzi persecutions. Even the United States Senate took a stand against my mother who for years was not able to come back to the United States.

How Everything Began

Letters and Memories
by Ingrid Bergman and Roberto Rossellini

Dear Mr Rossellini,

I saw your films *Open City* and *Paisan*, and enjoyed them very much. If you need a Swedish actress who speaks English very well, who has not forgotten her German, who is not very understandable in French, and who in Italian knows only 'ti amo', I am ready to come and make a film with you.

Ingrid Bergman

The cable arrived on May 8, 1948, at 1220 Benedict Canyon Drive, Beverly Hills, the home of Petter Lindström and Ingrid Bergman:

I JUST RECEIVED WITH GREAT EMOTION YOUR LETTER WHICH HAPPENS TO ARRIVE ON THE ANNIVERSARY OF MY BIRTHDAY AS THE MOST PRECIOUS GIFT. IT IS ABSOLUTELY TRUE THAT I DREAMED TO MAKE A FILM WITH YOU AND FROM THIS MOMENT I WILL DO EVERYTHING POSSIBLE. I WILL WRITE YOU A LONG LETTER TO SUBMIT TO YOU MY IDEAS. WITH MY ADMIRATION PLEASE ACCEPT THE EXPRESSION OF MY GRATITUDE TOGETHER WITH MY BEST REGARDS. ROBERTO ROSSELLINI, HOTEL EXCELSIOR, ROME.

Shortly after this, his letter arrived:

Dear Mrs. Bergman,

I have waited a long time before writing, because I wanted to make sure what I was going to propose to you. But first of all I must say that my way of working is extremely personal. I do not prepare a scenario, which I think terribly limits the scope of work. Of course I start out with very precise ideas and a mixture of dialogues and intentions which, as things go on, I select and improve. Having said so much, I must indeed make you aware of the extraordinary excitement which the mere prospect of having the possibility to work with you, procures me.

Some time ago ... I think it was at the end of February last, I was travelling by car along the Sabine (a region north of Rome). Near the source of the Farfa an unusual scene caught my attention. In a field surrounded by a tall barbed-wire fence, several women were turning round just like mild lambs in a pasture. I drew near and understood they were foreign women: Yugoslavs, Polish, Rumanians, Greek, Germans, Latvians, Lithuanians, Hungarians. Driven away from their native countries by the war, they had wandered over half Europe, known the horror of concentration camps, compulsory work and night plunder. They had been the easy prey of the soldiers of twenty different nations. Now parked up by the police, they lived in this camp awaiting their return home.

A guard ordered me to go away. One must not speak to these undesirable women. At the further end of the field, behind the barbed wires, far away from the others, a woman was looking at me, alone, fair, all dressed in black. Heeding not the calls of

the guards, I drew nearer. She only knew a few words of Italian and as she pronounced them, the very effort gave a rosy tint to her cheeks. She was from Latvia. In her clear eyes, one could read a mute intense despair. I put my hand through the barbed wires and she seized my arm, just like a shipwrecked would clutch at a floating board. The guard drew near, quite menacing. I got back to my car.

The remembrance of this women haunted me. I succeeded in obtaining authorization to visit the camp. She was no longer there. The Commander told me she had run away. The other women told me she had gone away with a soldier. They could have married and, with him, she could have remained in Italy. He was from the Lipari Islands.

Shall we go together and look for her? Shall we together visualize her life in the little village near Stromboli, where the soldier took her? Very probably, you do not know the Lipari Islands: in fact very few Italians know them. They earned a sad fame during fascism, because it is there that the enemies of the Fascist Government were confined. There are seven volcanoes in the Tyrrhenian Sea, north of Sicily. One of them, the Stromboli, is continually active. At the foot of the volcano, in a bay, springs up the little village. A few white houses, all cracked by the earthquakes. The inhabitants make a living out of fishing and the little they can pluck up from the barren land.

I tried to imagine the life of the Latvian girl, so tall, so fair, in this island of fire and ashes, amidst the fisherman, small and swarthy, amongst the women with the glowing eyes, pale and deformed by child birth, with no means to communicate with these people of Phoenician habits, who speak a rough dialect, all mixed up with Greek words, and with no means either to communicate with him, with the man she got hold of at the

camp of Farfa. Having looked into each other's eyes, they had found their souls. She, in these glowing, intelligent, swift eyes of his, had discovered a tormented, simple, strong, tender man. She followed this man, being certain that she had found an uncommon creature, a saviour, a refuge and a protection after so many years of anguish and beastly life, and she would have had the joy to remain in Italy, this mild and green land where both man and nature are to a human scale.

But instead she is stranded in this savage island, all shaken up by the vomiting volcano, and where the earth is so dark and the sea looks like mud saturated with sulphur. And the man lives beside her and loves her with a kind of savage fury just like an animal not knowing how to struggle for life and accepting placidly to live in deepest misery.

Even the God that the people worship seems different from hers. How could the austere Lutheran God she used to pray to, when a child, in the frigid churches of her native country, possibly stand comparison with these numerous saints of various hues.

The woman tries to rebel and tear herself away from the obsession. But on all sides, the sea bars the way and there is no possible escape. Frantic with despair, unable to withstand it any longer, she yet entertains an ultimate hope of a miracle that will save her - not realizing that a profound change is already operating within herself.

Suddenly the woman understands the value of the eternal truth which rules human lives; she understands the mighty power of he who possesses nothing, this extraordinary strength which procures complete freedom. In reality she becomes another St Francis. An intense feeling of joy springs out from her heart, an immense joy of living.

I do not know if in this letter, I have been able to express the fullness of my meaning. I know it is difficult to give concrete meaning to ideas and sensations which can only receive life through imagination.

To relate, I must see: Cinema relates with the camera, but I am certain, I feel, that with you near me, I could give life to a human creature who, following hard and bitter experiences, finds peace at last and complete freedom from all selfishness. That being the only true happiness which has ever been conceded to mankind, making life more simple and nearer to creation.

Could you possibly come to Europe? I could invite you for a trip to Italy and we could go over this thing at leisure? Would you like me to go in for this film? When? What do you think of it? Excuse me for all these questions but I could go on questioning you forever.

Pray believe in my enthusiasm.

Yours Roberto Rossellini

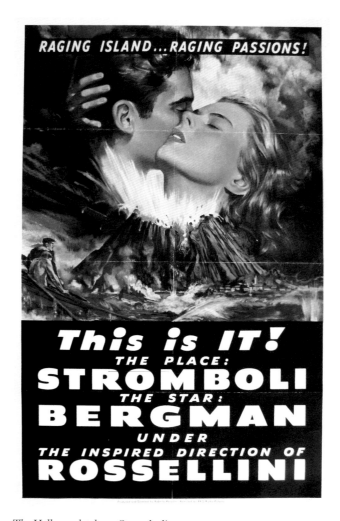

The Hollywood take on Stromboli.

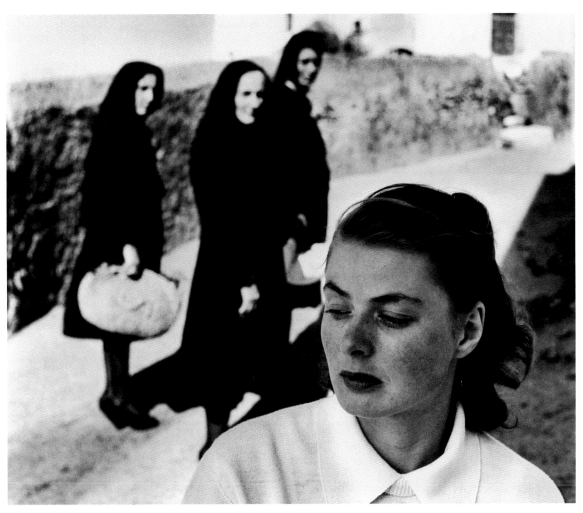

Gordon Parks' photo which for me captures the true essence of Stromboli.

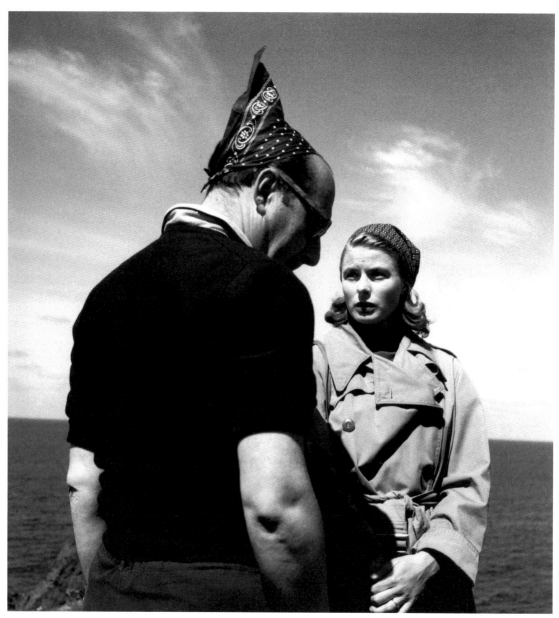

Roberto Rossellini and Ingrid Bergman on Stromboli, 1949. Photo: Federico Pattelani

Roberto Rossellini

from: Dix ans de cinéma, Cahiers du Cinéma, 1955

On 8 May 1948, I received a letter from Ingrid Bergman saying that she had seen *Rome, Open City* and *Paisan* and would like to make a film with me. The 8th of May was my birthday. The evening of the 7th, I received a telephone call from Mr Potsius of "Minerva Films", the company who had bought *Rome, Open City*. Mr Potsius wanted to give me a beautiful present. I thought he was referring to my birthday, especially as I had sold him *Rome, Open City* for a mere song when it was considered "tripe" and that he had "exploited" it when it was later considered to be a "masterpiece". The next day, he brought me Ingrid's letter, which he had already read. The Minerva film office had burned down. Mr. Potsius was opening all the mail that kept coming without checking if it was or was not addressed to him. I replied straight away to Ingrid and on 17 January 1949, five years to the day after shooting the first frames of *Rome, Open City*, I arrived in Hollywood to discuss the idea of *Stromboli*.

A great American producer appeared very interested in our project and we had long conversations over numerous lunches, dinners and breakfasts. This is how I learnt English as the same words were endlessly repeated in the course of our

conversations. This producer talked about only aesthetic considerations; he explained to me his wide experience in films and tried to convince me to use a script for my film. Some of his arguments were very clever but I was strictly opposed to having a script for reasons I have mention-ed a hundred times*. One evening, Ingrid and I were summon-ed by telephone to his office; he had organised a press conference and announced the film to the press; we were very surprised, nevertheless we went to the location where we were photographed signing a fake contract.

From this day onwards, the discussions between the producer and myself took a far more pragmatic turn and I decided to decline his offer soon after.

In Hollywood, where there were so many artists, I felt very disorientated and I couldn't understand – at least at the time – the atmosphere of contempt, and chauvinism. I have to say that despite this, I made very good friends there.

———————

* I am asked to summarise them again. Here they are:
 a) Because I shoot my films in real interiors and exteriors, I improvise my stage production in relation to the setting in which I find myself. Therefore, the left column of the script where the sets are described would remain white.
 b) I choose most of my actors on the spot, at the time of filming; I cannot, before seeing them, write the dialogue, which would inevitably be theatrical and false. The right column of the script where the dialogue is written would also stay white …
 c) Finally, I really believe in the inspiration of the moment …

On 2 March, I returned to Italy where Ingrid joined me on the 19th.

At the beginning of April, we began to film in Stromboli just as the scandal over our private lives broke.

What started all this? How could rumours of a divorce and a new possible marriage create such scandal?

In the world of cinema, and in particular in America where divorce is legal, divorces are treated like a common occurrence.

I have already said that many times, generally speaking, the atmosphere in Hollywood was not favourable to me. Ingrid was an actress, I was a film director: it was natural that we wished to make a film together. But Hollywood received the news like an insult, a blow to its prestige.

Stromboli was a small island, very isolated from the rest of the world. No telephone, no electricity; a boat links it to the mainland once a week; news from the outside would reach us late. We only realised that a scandal had broken out when we saw journalists, photographers, and even friends – let's not forget the publicity and public relations "experts" – arrive to give advice in our best common interest. I was surprised to discover that there were so many experts in the world.

The whole wave of sensational news no doubt had one goal: to intimidate us. Faced with the relentless "sensational headlines" of the press, the "experts" were suggesting only one thing: to deny everything.

When Ingrid and I offered to put the film on hold, or even to simply abandon it in order to calmly solve the situation, with time to reflect and to step back – the "experts" disagreed and advised us to continue filming. Work above all. The show must go on!

Ingrid Bergman during the filming of Stromboli, *1949. Photo: Federico Pattelani*

Friends and "experts" were endlessly warning us about the severe dangers that this scandal caused to our careers.

If there was a premeditated plan to force us apart – counting on our cowardice or our hypocrisy and by stressing the risks that we were running – it was of course a miscalculation. For us Europeans, and for me in particular, with no experience in this area of "press scandals", it was difficult to understand American journalism.

————————

Ingrid Bergman during the filming of 'Stromboli', *1949. Photo: Gordon Parks*

To go back to *Stromboli*, I was interested to deal with the theme of cynicism, a feeling which represented the greatest danger after the war. Karin takes advantage of the innocent love of a soldier, a poor and primitive being, marrying him for the sole purpose of leaving the internment camp: she trades the barbed wired for the island, but she finds herself even more of "a prisoner"; she had other dreams.

A strong and decisive woman, who lived through the dramas and difficulties of the war, she is now the victim of small silly problems: a husband who is brutish, a small bare island and a prisoner twice over because she is pregnant. She considers that to be pregnant is not important, she considers it humiliating, and beastly; she decides therefore to run away. But at the top of the volcano, which she has to climb in order to reach the little port on the other side of the island, in the midst of a hostile environment, broken by fatigue, struck down by terror and desperation, she calls upon God.

"My God" is the most simple and primitive invocation to be expressed by a human being overcome by suffering.

Whether it is a mere impulse or the expression of a belief, it is always the expression of deep mortification. This mortification is necessary for the spiritual, deep understanding of life.

Ingrid Bergman
Fragments from her autobiography My Story

Of course when I sent my telegram to Amalfi to Roberto Rossellini, I'd no idea that I would be creating something of a domestic explosion. I didn't know that Anna Magnani was with him, and she knew very little or nothing about me. For reasons which are quite obvious now, he'd kept very secretive about the whole thing. But she was a woman. And she knew that something was in the air.

———

Isabella's Note on Anna Magnani:
Anna Magnani was the greatest actress of Neo-realism. She acted with the non-professional actors who were preferred by the neo-realist directors always seeking authentic looks and feelings. Anna's "acting" was unperceivable, blending, improvising, adjusting and serving the neorealist intentions with great mastery. She was my father's lover – she was known on screen and off for her great persona and strength. The little anecdote I am reporting is written in all biographies (mother's, father's and Anna's).

Anna and Daddy were spending a weekend at the Hotel Luna in Amalfi. Daddy told the concierge he was expecting a telegram from Los Angeles and to please give it to him privately, not in front of Anna Magnani. But the stupid concierge, as Father and Anna passed him in the hall on their way to the restaurant, winked at Dad. Anna got it and got it all. Sitting at the table, they ordered pasta. Pleasantly she asked, "Roberto, do you want more sauce? A bit more olive oil? Some parmigiano?" She tossed the spaghetti, and when it was all ready to be eaten, she poured the contents over Father's head. That was the beginning of the end of their relationship…

———

Anna Magnani. Photo: Herbert List, 1950

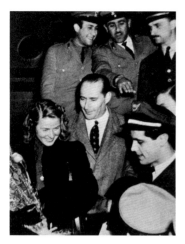

Rome 1949

Arriving in Rome was just like something out of a dream. I've never experienced a welcome like it anywhere else in the world. It was a fiesta – everyone laughing and shouting and waving and going mad. There were so many people at the airport you'd think it was a queen arriving, instead of just me. Roberto shoved a big bouquet of flowers into my arms and we forced our way into the cars. Roberto pushed me into his sporty red Cisitalia, and drove off into Rome, straight to the Excelsior Hotel. And the crowds were there, too. We just couldn't get through them to the front door.

Roberto immediately started fighting the photographers; that was his normal behaviour with photographers. There he was hitting out with his fist and trying to smash a way through to the door. He tore one photographer's jacket right off at the arm, and the next day he felt sorry about it and sent him a new jacket. We finally managed to get inside Roberto's apartment where a party was waiting. All Roberto's friends were there. Federico Fellini had put marvellous little caricatures on the walls: drawing of Roberto and me and the island of Stromboli. And there was champagne and everyone was laughing and chattering. Roberto had put little gifts everywhere. I was simply overwhelmed.

I think that deep down I was in love with Roberto from the moment I saw *Open City,* for I could never get over the fact that he was always there in my thoughts.

Roberto wanted me to meet all his friends; he wanted to show me Naples and Capri and Amalfi and a dozen places I'd never

heard of. Everything was so new to me: the country and the people, their outgoing way of life, the beauty of it. And Roberto seemed to know everything there was to know.

————————

I have a sweet photograph in which I look so happy it is unbelievable. We are in a little place where people go dancing. I think it must be the only time I ever danced with Roberto, because he's just not a dancer. But that evening he danced. I think he was doing everything to win me over.

He was wonderful at recounting the history of Italy; he knew everything that had happened throughout its history. And if he didn't know it, I think he made it up. He knew all about the history and the monuments and ruins; he knew all about the legends; and he knew practically everybody in Italy as far as I could see. As we walked around, the photographers followed us everywhere, and Roberto was so calm and quiet and happy that he didn't even bother to punch them. And then came that famous photo – which *Life* magazine printed – on the Amalfi coast as we climbed the steps toward one of those round towers. We were hand in hand, and that went all over the world showing what a loose woman I was …

The fact that Roberto disliked actors was now made clear to me. Oh yes, he had many friends among actors because he found them amusing, but he refused to believe that a man could have so much vanity that he could go out and perform on a stage; be like a rooster out there; comb his hair and put on make-up. "You watch any actor pass a mirror," he said. "I don't mind women because they always look in mirrors anyway, but an actor can't bear to pass a mirror without adjusting his tie or brushing back a strand of hair or doing something to himself."

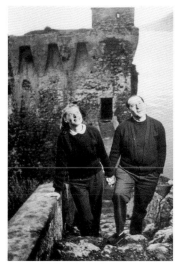

Ingrid Bergman and Roberto Rossellini, Amalfi Coast, 1949. Photo: Ivo Meldolesi

From the very first, I didn't have any difficulty in working and communicating with Roberto. Sometimes he had a bit of trouble explaining what he wanted, but after that it was a communication by thought process. I could read his eyes. Even when he couldn't explain in words what he wanted, I felt *what* he wanted…

––––––––

We were in such a hurry to get through that movie before it showed. And then, of course, I grew terribly big. Pia was now

Roberto Rossellini and Ingrid Bergman on Stromboli, 1949. Photo: Gordon Parks

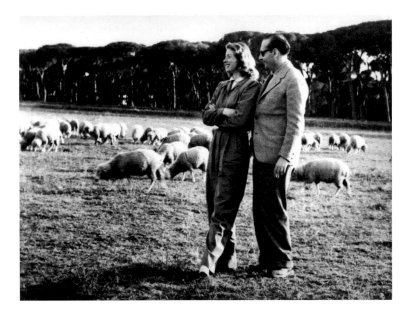

Ingrid Bergman and
Roberto Rossellini, Italy 1949.

thirteen, Robertino two, and having had two children before, I didn't understand why I looked like an elephant. I went to the doctors and they X-rayed me because they couldn't hear two hearts; they thought the child was maybe misplaced.

I sat and waited and the doctor came out with a smile up around his ears so I knew nothing was wrong. I asked, "How many?" he told me he thought only two; he had seen four feet and four hands but they were behind each other so he could only hear one heart.

I just couldn't wait to get home. I telephoned from the hospital and told Roberto. And he telephoned all Rome, he was so proud of what he had done – two at a time. My first reaction was worry: how in the world did you take care of two babies at the same time?

I got so big I couldn't sleep at all, and I couldn't get into any clothes. Finally I couldn't eat, so eventually I spent the last

month in the hospital. They fed me intravenously, and I was exercising on the roof, walking around in a big robe. The press was down below keeping watch and I kept waving to them. They could only photograph my face with a telephoto lens as I peered over and laughed at them. They shouted up, "When?" And I said, "I hope soon, because I'm tired of this."

Anyway they never did come, and the doctors began to get very worried because twins should come ahead of time. Mine were now beyond the time that they were supposed to come. So they wanted to induce the birth. I called Roberto – he was working on location – and I said, "How can we allow this? We choose their birthday. That is not right. All the stars, the astrological signs, the moon, and the constellations will be confused. Your birthday is supposed to have some meaning in the scheme of things isn't it? Their horoscopes will never be right if I decide what day they come. I want to wait." Roberto agreed with me, but then the doctors got on to Roberto and convinced him – to hell with the constellations. It was just getting too dangerous. So he talked to me and I saw the sense in that. Come the morning, the doctor arrived with his injection, and I said, "Let me ring Roberto."

"It's the eighteenth of June," I said. "Do you think that's a good day?" "Eighteenth of June? Sure that's a good day. Go ahead."

———————

Someone wrote somewhere about my life with Roberto that although I was probably always troubled by my puritanical conscience, with him I had found a world that for me was probably better than most of us ever attain. And that is true. I did have marvellous happiness with Roberto as well as deep trou-

bles. But trouble is a part of one's life. If you have never had any trouble, if you have never cried, if you have never been really miserable and thought that you could not go on, what kind of understanding would you have for other people who are in trouble? You wouldn't have any patience with them. Now you know what it feels like. I think that's what life is all about. You have to have your ups and downs, you can't be happy all the time. I would think a person who is always happy would be a big bore. And Roberto was never a bore.

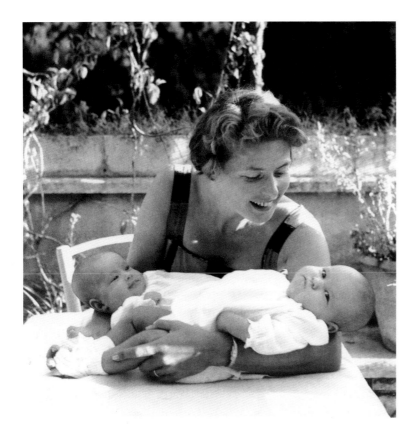

My mother with my twin Ingrid and me, 1952. Photo: David Seymour

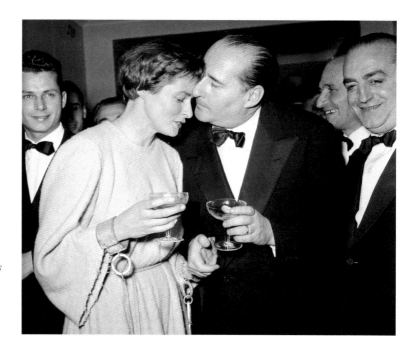

Roberto Rossellini congratulating his wife Ingrid Bergman after the first night of 'Jeanne d'Arc', *which he directed, in Neapel 1953.*

I tried many ways to live with him. I remember saying to him during the difficulties we had with money, "Look, let us go bankrupt. People go bankrupt, don't they? What can happen? We don't go to jail, do we? Let us just live on whatever we have. Let them take the house away. Give it all away, everything, everything. And we start from nothing. We take a small apartment. I shall do the cleaning, the scrubbing, cook the food. We won't have any servants or anything.

And Roberto looked at me as if I were mad. "*That* life isn't worth living," he said. That was such a slap in my face because I thought I offered him everything and he wouldn't even think of it. "That life is not worth living!" Life had to be in the grand style.

People thought I acted strangely, for now the newspapers were full of how Roberto had pursued, fallen in love with, and run off with this Indian producer's wife. But people do a lot of strange things. And you have to weigh their actions. You have to balance them. You say, "This is good, and that is not so good, but what is really important?" Maybe he had a love affair? So what! That wasn't important. He had great talent, even genius. No one could take that away from him. And talent is important.

When he arrived back at the Paris airport, I went to meet him. That confused all the newspaper reporters who were around me clamouring, "Miss Bergman, I understand your husband has run away with an Indian girl?" "Hasn't he eloped with the wife of an Indian producer, Miss Bergman?" And I said, "Has he? I didn't know that. I'm just here to meet him." Roberto came into the airport and I threw myself into his arms. He gave me a great big hug and we kissed; this photograph went around the world.

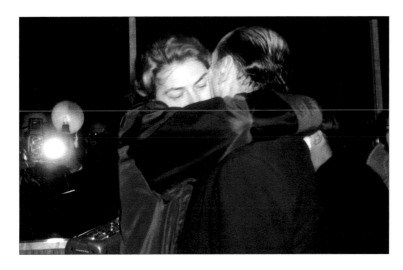

Ingrid Bergman and Roberto Rossellini at the airport in Paris after his return from India, 1957. Photo: René Jarlan

Now I was in the Raphael Hotel suite with Roberto, and I said very gently, "Look Roberto, would you like a divorce?" I remember he leaned back in the chair, still twiddling with that lock of hair, and looked at the ceiling light and didn't answer. Perhaps he hadn't heard me. I said again, very quietly, "Roberto, do you think it a good idea if we get a divorce?" Not a word came out, just the looking at the light. And I thought, I'm not going to repeat myself three times. I'll just wait. I waited and waited. It seemed like eternity. He just went on twiddling with that lock of hair, and his face was very sad. Then finally he said, very slowly, "Yes, I'm tired of being Mr Bergman." I felt that was a strange thing to say because he was always a big name, always himself, always Roberto Rossellini, never but *never* Mr Bergman. "All right," I said. "I understand. We'll get a divorce." We had resolved all those difficult years. We were happy. We kissed each other. Then I told him how I'd met Sonali, and I wished him luck.

He said, "You must have the children. They belong to their mother. But there are two things I must ask you." "Yes, what are they?" "The children must never go to America." He hated the United States and Howard Hughes (who produced *Stromboli* and released it in the US in a re-edited version without Roberto's consent). "Never go to America! How can I prevent my children when they grow up from going to America? Let's say we give them a European education, but when they're eighteen we've got to give them liberty to go where they please, including America if they want to."

Roberto agreed. "So what's the second thing?" I enquired.

"That you'll never marry again."

"I should never marry again?"

"That's right, not at your age."

"My age! Look, you're almost ten years older than I am. You're going out with a lovely young Indian woman. You've found someone else who is young and beautiful, but I'm not supposed to go out and find someone who is young and beautiful. I'm not to marry again. You have no right to prevent me."

"You are supposed to take care of the children. You have three children, four children with Pia. I mean, what more do you want?"

"I'm not going to promise you that," I said. I began to laugh. It was all very funny, I couldn't help laughing. That was Roberto.

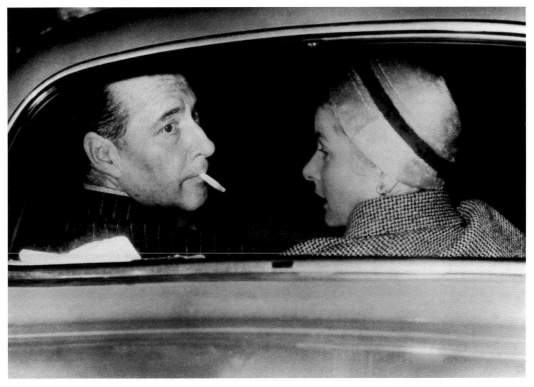

My parents, driving to the divorce courts, 1957

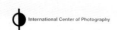
International Center of Photography

March 15, 2005

Ms. Isabella Rossellini
 Fifth Avenue
Suite 814
New York, New York

Dear Isabella Rossellini:

We have recently come across photographs taken by Robert Capa during the filming of John Huston's "Beat the Devil".

On the contact sheet we were happily surprised to see the enclosed photograph, which we wish to share with you.

Best wishes to you from Cornell Capa, and all of us at ICP.

Sincerely,

Anna Winand

Anna Winand
Cornell and Robert Capa
Archive Office

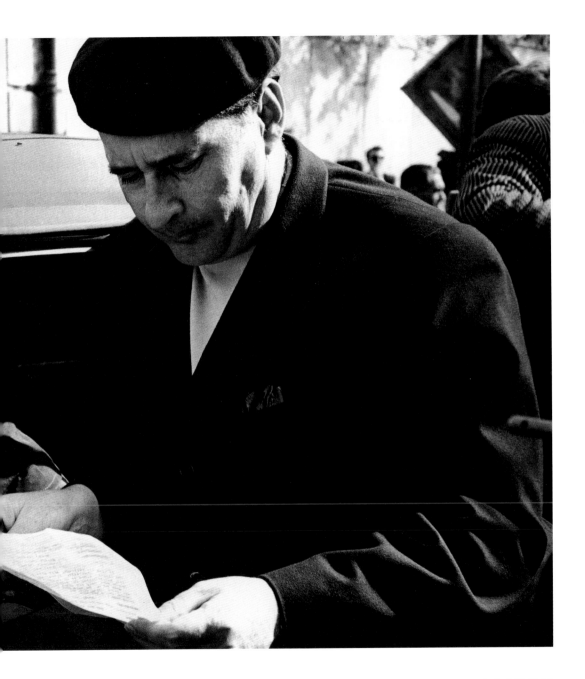

Roberto Rossellini: How I Saw It

Mine is a profession that needs to be learned day by day, and there is no end to describing it: it is the profession of being human. And what is a human? – a being who stands straight and rises on tiptoe in order to look further into the universe.

———————

In my films I give a great deal of importance to detail. I introduce a number of messages so as to allow each viewer to approach things according to his own nature. I prefer a long master shot to editing.

———————

I am much rebuked for not going out of my way to seduce the audience, for filming "cold", never taking the spectator by the shoulders and telling him: "This is how you must do your viewing, this is how you must think; mind, here is where you are to feel touched!"

I want things to unfold, leave the spectators alone in front of the image, free to make their own choices, as the eye's retina

does when it registers reality (I try to film as close as possible to what the eye sees). In this way I demonstrate my complete trust in the viewers.

Mystery, doubt and faith coexist: it is up to the public to sort them out.

The *nouvelle vague* film directors have said, and repeated to anyone who wants to understand, that thanks to my example, they have succeeded in freeing themselves from films dictated exclusively by commercial criteria. They have managed to escape both from the star system and from the categories that it has created: thrillers, westerns, action movies, psychological dramas, horror, fantasy, etc. In a certain sense they are my children. At least they claim Rossellinian descent.

But if this is true, what have most of them done with the inheritance I have left them? CINÉMA D' AUTEUR! For twenty years, apart from Godard, who is a special case, they carry on unflaggingly about the torments of puberty. What is the use of freeing the cinema from the power of money only to have it fall under the power of individual phantasms in the hope that these become collective phantasms and lead to success? This misconception is more serious than the others, because it deviates from its ultimate goal (of freeing cinema from commercialism). It betrays what had been my great hope for cinema: knowledge. It is time that I denounced a fundamental misconception about me: I am not a film-maker.

I remember my return from India, when I divorced from Ingrid. The world press dragged me through the mud. I was a scoundrel, an ignoble individual, I deserved nothing but scorn from upright folk, etc. … Just take a look at the papers of the time.

… So I lived holed up with my Indian woman in a studio in Rue Danièle Casanova that belonged to Cartier-Bresson, and only answered the telephone after a signal agreed with the few friends who knew where I was.

One day the telephone rang at six in the morning. I answered anxiously. What new catastrophe? It was Mary Merson who in her fine tragic actress's voice told me: "Roberto, dear, you are in luck! What an opportunity! Truly you are a lucky man."

I interrupted to ask what was making her so excited. "Go down and buy *L'Aurore*," she told me. "You can't sink lower than that! It means that now you can only rise."

After the first moment of surprise, I have to admit she was right. In certain fields women see the truth at once. Some of them have opened my eyes even when this was painful.

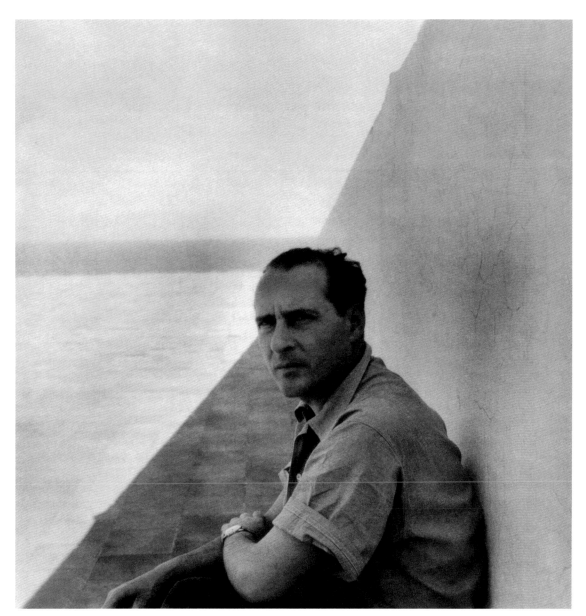

Roberto Rossellini 1947. Photo by Clifford Coffin

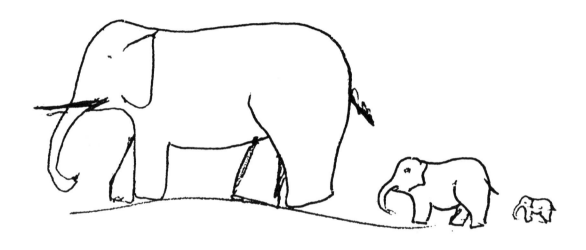

Roberto Rossellini's illustrations from his letter to his children, January 1957.

Roberto Rossellini's letter to his children, written from India

17 January 1957

My adored children, Robertino, darling Dindina {Ingrid Jr.}, my chubby-cheek Giggia {Isabella}.

It's ages since I last wrote. I've been through some very sad times and I didn't want to pass this sadness of mine on to you. I have been travelling all over for a week with a gentleman called Nehru. He is the one who is in charge here.

I've travelled aboard his 'plane and we have flown over forests where wild elephants and tigers live.

I have also travelled with a gentleman who is known as the Dalai Lama, who is the spiritual head (like the Pope) of all the Buddhists in the world.

He is a Tibetan, that is a Chinese who lives in the world's highest nation, that is Tibet.

I have seen so many other things that I shall show you in the film when I'm back, and when you are older you'll be able to read about them in a book I'm writing. And then … And then I've been dreaming about you.

I dream of you every night. I have all of you so close and present to me every, every night. This is of great consolation to me even if the waking up is all the more painful. You have no idea, my children, how much love this old heart of mine is capable of.

You know that the world is round and that it spins on its own axis and goes around the sun. So the passage of the light of the sun on the earth gives us the hours.

I'll explain with this sketch:

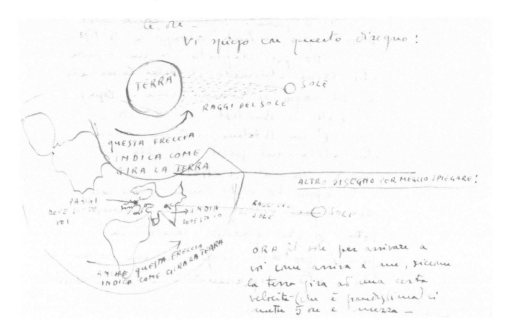

Now, the sun, to arrive where you are as it arrives where I am, because the earth spins at a given speed (which is enormous), takes five and a half hours.

And so when you get up at 8 in the morning and you wake up all chirruping and Robin [Roberto Jr.] with his eyes still a bit swollen from sleep takes his school bag to go to school, I am already seated at the table (not to eat a good plate of pasta for the simple reason that there isn't any here) but to eat. When you go to bed at night I've already been fast asleep for many hours and I'm practically ready to get up to start another day.

And it is precisely during these hours when I'm asleep and you're still awake that my spirit hastens to you to recover a bit

of strength and comfort and then returns to shut itself up in my body to reawaken me and get me up still alive.

You are awake and playing, so maybe you cannot feel my spirit kissing you, caressing you, touching you to recover strength. Because the spirit, which is all life, is transparent as air, stronger but lighter than a bird's feather.

I'm sending you some photos I've taken here. Thank Cesira [the cook] who has remembered to write to me so often. Ask Mademoiselle [baby-sitter] why she never writes to me. I see that she is the one who prepares the envelopes for your letters. I would like it if she too wrote to me now and then about you. Give her my fondest greetings and give her a hug from me.

To you, Robin dear, I have to say that your drawings are ever more beautiful. Dindi's drawings are also beautiful (dear Robin, your drawings are more those of a little man and those of Dindi are still those of a little girl). From Giggia I have received the sweetest letters but drawings which were funny because they were doodled with her usual impatience.

On the back of the photos I'm putting in pencil what they are of.

I'm sending you lots and lots and lots and lots and lots and lots and lots and lots and lots and lots and lots and lots and lots and lots and lots and lots and ever such lots of kisses with all my love.

Papà

P.S. By the way, did you ever receive a great big photo of me? What do you think of it?

Keyring, which Ingrid Bergmann had made for her husband after Federico Fellini's drawing of Roberto Rossellini.
On the back the words "Io mi chiamo Rossellini – My name is Rossellini" are engraved, Roberto Rossellini's typical introductory phrase. Photo: Filiberto Scarpelli

IV. The Holy Spirits

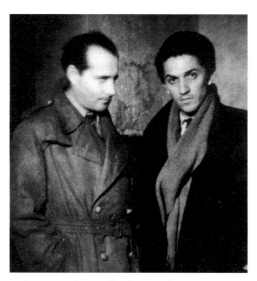

Roberto Rossellini and Federico Fellini, during the filming of Paisàn *1946.*

Quotes by Federico Fellini on Roberto Rossellini

One day, I was drawing a caricature when a man entered who looked gaunt, as if he might be a displaced person or maybe someone who had been a prisoner of war. I recognized him even with his hat pulled down and his overcoat collar turned up and only a little bit of his face showing. He was Roberto Rossellini.

[…]

Rossellini had come to ask me to write a scenario for a film which would become *Open City*. He told me about a script he had from the writer Sergio Amidei about a priest who had been executed by the Germans. He said he had backing from a rich countess. Women loved Rossellini. I tried to understand why, because I was interested in being loved by women. I didn't understand then what this fascination he had was, but now I *think* I do. It was because he was fascinated by *them*. Women like a man who is interested in them. He would think it was he who was spinning a web, then *he* would be caught in it. Love affairs and films, films and love affairs were his life.

[…]

What Rossellini did convey to me was a feeling, his love for directing films, which helped me to realize my own love of

directing. When I first was on movie sets, to do interviews as a journalist, and then after I had worked on scripts, I did not immediately recognize the film set as the place where I would find my greatest fulfilment and happiness, what Tennessee Williams called "the home of the heart". It wasn't until I worked with Roberto Rossellini in the 1940s that I found the meaning in life for me.

[...]

Open City was written in a week, one of the kitchen-table collaborations. I was credited for writing and as assistant director. I deserved it, but everyone doesn't give what you deserve. Robertino was never stingy with anything.

As a boy, through his father, who was an important builder – he had built some of the major cinemas in Rome – Roberto and his brother, Renzo, had free movie privileges at some of the biggest and best movie theatres. Robertino always took a crowd of boys in with him

We made *Open City* and *Paisan* just after the liberation of Italy by the U.S. military forces. We did *Open City* for less than $20,000, so you can imagine what kind of salaries we had. I, personally, have no idea what I was paid back then. The money was of absolutely no interest to me as long as I could survive. I was doing what I wanted to do with people I wanted to work with.

[...]

Neo-realism was the natural way in Italy in 1945. There was no possibility of anything else. With Cinecittà in shambles, you had to shoot at the real location, with natural light, if you were lucky enough to have film. It was an art form invented

by necessity. A neo-realist was in reality any practical person who wanted to work.

<p style="text-align:center">[...]</p>

Rossellini was a charismatic personality. Working with him, I realized making films was exactly what I wanted to do, and he encouraged me in the belief that it was an art form I could master. He was older than I, ahead of me in so many ways.

I remember a moment that I know was a turning point in my career, in my life. Rossellini was working in a small dark room, peering intently at the Moviola. He didn't even hear me enter. His intensity was so great that he was living on that screen.

The images on the screen were silent. I thought, What a wonderful way to see your film – silent – so that the visual is everything.

He felt my presence and wordlessly beckoned to me to come closer and share the experience with him. I think that was a moment that shaped my life.

François Truffaut and Roberto Rossellini, 1962.

How did you do that,
Signor Rossellini?

Interview by François Truffaut and Eric Rohmer

Jacques Rivette recently wrote: "There is on the one hand Italian cinema and on the other the work of Rossellini." What he meant was that you stood aside from the neo-realist movement which embraces the vast majority of Italian film directors ...

Yes, from a certain kind of neo-realism; but what exactly is meant by the term? It is only a label. For me neo-realism is above all a moral standpoint from which to look at the world.

It tends to be said that there is a fault line in your work after Stromboli.

This may be true. It's hard to judge oneself; as for me – and you're not to give this too much importance – it seems to me I'm wholly consistent. I believe I'm the same human being who looks at things all in the same way.

Given that we enjoy your films and believe we understand them, we find it all the harder to follow the arguments of those who dislike them. The novelty of your style may have initially put off some of our colleagues: but it is a fact that some of them changed their minds – for instance, many of those who didn't care for Europe '51 *at Venice thought differently when it was released in Paris.*

It is amusing to read what the critics wrote about my early

films. *Open City*: "Rossellini confuses a news story with art." At Cannes, where it was shown one afternoon, the film passed unnoticed; then, little by little, it began to be taken seriously, even to the point of exaggeration. I remember how shocked I was when *Paisan* came out. I believed deeply in that film: it is one of my favourites. The first Italian review that came to hand spoke of the "obfuscated mind of the director" and continued on the same tone. I don't think any film could have been more disparaged than *Germany Year Zero*. Nowadays it is constantly being mentioned. I find this delay hard to understand.

Reverting to your style, what can be disconcerting is the absence of so-called "cinematographic effects", you don't underline the important moments, you remain not merely objective but quite impassive; one has the impression that everything is on the same plane, as if intentionally so.

I try always to remain impassive. I find that what is surprising, extraordinary, touching in people is precisely the fact that great deeds or things of importance come about in *just* the same way, just as calmly as the trivia of daily life.

What of the films preceding 'Open City', were they made in the same spirit? We haven't seen them.

They were made to the same purpose.

In The White Ship, *which came three years before* Open City, *there were no professional actors. Was this neo-realism "avant la lettre"?*

It was precisely the same moral attitude. You know what a warship is? The frightening thing is, the life of the vessel must be preserved at all costs. On board there are little men who

know absolutely nothing, poor folk recruited from the countryside, dragged off to attend to machines they don't understand: all they know is that when a red light comes on they have to press a button, if it's a green light they have to pull down a lever. That's all there is to it. They are imprisoned in this life; there they are, nailed to their sector, nailed in an absolute sense because, if a torpedo strikes the ship, part of it will be flooded but the ship itself will be saved. This is the frightening, the heroic, situation for these poor folks who know nothing. In a vessel such as this they don't even hear the battle; the ventilators are blocked up, so that the fumes from any possible explosion will not be spread throughout the ship. There they are in an unsufferable atmosphere, the heat, behind steel plating, not shut in – sealed in – deafened by a vague and incomprehensible racket. They know nothing: they just have to watch for a red or a green light. Every now and then a loudspeaker says something about the Fatherland, then all reverts to silence.

The next film, The Man with the Cross …
 … puts the same question: men with hope, men without hope.

Your Christian idea was less explicit before Stromboli'. *Some critics were put off by a film director being a Catholic, one who wore his Catholicism on his sleeve.*
 Many Catholics were against me.

Is it true that the proof of this was in The Miracle?
 For me, *The Miracle* is a Catholic film one hundred per cent. My starting point was a sermon by St Bernardino of Siena

concerning a saint called Bonino. A peasant goes into the fields with his two-year-old son and a dog. He leaves the child and the dog in the shade of an oak and goes to his work. When he gets back he finds the child's throat torn open, with traces of teeth on his neck; in his anguish the father slaughters the dog, and only at that moment does he notice a large snake and realises his mistake. Conscious of the injustice he has committed, he buries the dog beneath some nearby rocks and carves an inscription on its grave: "Here lies Bonino (the name of the dog), slain by the ferocity of men." Several centuries elapse, there's a road past the grave, wayfarers stop in the shade of the oak and read the epitaph. Little by little they start praying, asking the intercession of the unfortunate victim buried there: the miracles resulting are so numerous that the local people build a beautiful church and a tomb in which to transfer the body of Bonino. And then they realise that the body is that of a dog. As you can understand, the story in *The Miracle* is not all that different: a poor woman, beyond a sort of religious mania, nurtures a true, deep-rooted faith. She can believe in whatever she wants. That this may amount to blasphemy I admit; but her faith is so immense as to make up for it. What she did was absolutely human and normal; offering the breast to her son.

When I give a private screening of my films (to a small audience of twenty or thirty), the people come out quite overwhelmed, their eyes swollen with tears … The same people go to see the film in a cinema and hate it. This has happened to me so many times.

You cannot imagine how often I've met people, especially women, who've said to me: "Signor Rossellini, we are expecting a great film from you. But above all you are not to set

before us such horrible things. We beg you, make us a great, beautiful film."

––––––––––

Isabella's Note:
When 'The Miracle', *my father's film with Anna Magnani and written by Federico Fellini, came out in the USA in 1952 it was accused of blasphemy and taken out from the cinemas. The court case that followed was taken all the way up to the US Supreme Court, which ruled that films were a form of expression deserving of First Amendment Shield that protects freedom of speech.*

––––––––––

What is it you are saying in 'Europa 51'?

Do you know how the idea came to me? I was making *Francis, God's Minstrel* and was reciting the *Fioretti* to Fabrizi [Aldo Fabrizi]; after listening to me from start to finish, he turned to his secretary and said that St Francis "was off his head"; and the other added "quite mad". I was also inspired by something that happened in Rome during the war: a shopkeeper in Piazza Venezia was selling material on the black market. One day while his wife was serving a lady, he approached the customer and told her, "Take this material, lady, I'm making you a gift of it, because I want nothing to do with these underhand dealings; war is a horrible thing." Evidently after the customer left the shop, the man and his wife quarrelled and she made life impossible for him at home; but the moral problem remained. Given that they didn't sort matters out and the wife persisted in perpetrating crimes against his moral law,

what does the man do? He goes and turns himself in to the police: "I've done this, that and the other, I need to acquit myself of all these things." Then the police send him to a mental hospital… And the psychiatrist told me something rather worrying: "I examined him and realised that the only problem with this man was a moral one; I have to assess him as a scientist, not as a human being; as a scientist I have to see whether he will behave like most other humans. He wasn't behaving like most other humans, so I had him committed to an asylum." Science has its limitations, science has to calculate, measure, work in conformity with what it has acquired, with what it knows. That is the subject of *Europe '51*.

———

Isabella's Note on Europa 51:
Ingrid Bergman plays a modern saint. A wealthy woman, who is caught in an existential crisis when her son commits suicide, finds solice in spending her whole fortune on helping the poor. Her family and friends believe that she has lost her mind – grief-struck over the loss of her child – and commit her to an asylum.

———

And Italian Journey?
That's a film I'm very fond of; it was very important for me to show Italy, Naples, that strange atmosphere compounded of a very real, very immediate, very deep sentiment, the sense of eternal life: this is something that has quite vanished from the earth. In Naples, during the war, I witnessed something sensational. In the city you have the *bassi* – shops where you

make your purchases on the first floor; above are the living quarters; below there lived a family of sixteen; the smallest of the fourteen children was three and the biggest eighteen. They were all into the black market; their pockets were bulging with cash. Do you know what they bought with that pile of cash they had earned? They didn't buy themselves clothes, they didn't buy shoes, they bought coffins, stupendous coffins, with silver trimmings. What was the real meaning of this? Those poor folk led a ghastly life, they knew they counted for nothing here on earth, but they had this hope of eternal life, the hope of presenting themselves worthily to God. Something that truly brings tears to the eyes.

Besides, it must not be forgotten that Naples is the only city in the world in which a miracle takes place on a fixed date, 19 September, the miracle of San Gennaro. So much the worse for San Gennaro! If the miracle doesn't happen, they insult him … it is this portentous faith that governs everything. Here is the really heroic side of humanity, here is the true miracle, faith. This is how Italy is, the whole of it.

What part does improvisation play in your films?

As a rule the filming goes according to a pre-established plan. I hear the rhythm of the film. And that is maybe what makes me obscure.

In *Stromboli* the most important thing is the waiting during the fishing. It is in no way a documentary; there's more to it, I've tried to reproduce this eternal waiting of the fishermen under the sun; then that tremendous tragic moment when the tuna are slaughtered. Death erupting after the longest of waits. *You have won a reputation for filming without a scenario, constantly improvising …*

In part this is a myth. I have a mental picture of the "continuity" of my films; in addition, I have my pockets stuffed with notes; still, I have to admit that I've never really grasped the reason for having a scenario, unless to reassure the producers. The dialogues: I don't improvise them systematically, they are already written out, and if I give them to the actors at the last minute, that is only because I don't want the actor, or actress, to get too familiar with the words. I want to count on the spontaneity of the actors.

Abbreviated version of an interview, first published in *Cahiers du Cinéma*, No 37, July 1954, pp 1-12.

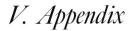

V. Appendix

Chronology

1906

8 May: Roberto Rossellini is born in Rome, the son of Angelo Giuseppe Rossellini and his wife Elettra Belan. His first movie impressions are films by Charlie Chaplin and King Vidor's *The Crowd*.

1917

He attents high school and then a boarding school run by the Nazarenes in Rome.

1923

Cuts short his studies of Philosophy and Literature. Leads a bohemian life, enthusiastic about fast cars and excessive parties. Tries to enter the filmindustry, works as a sound-engineer and cutter, makes short movies.

1937

Marries Marchella de Marchis, with whom he has two children: Romano (1937-46), Renzo Jr. (1941). His short movie *Prélude à l'après-midi d'un faune* is banned by the censors because of "obscenity". Becomes friends with the son of the Duce, Vittorio Mussolini, whose circle include other protagonists of neo-realisms such as Antonioni, Fellini and Visconti.

1941

Under the supervision of navy officer and director Francesco De Robertis, Rossellini makes his first feature film *La nave bianca*, a propaganda movie, as are his *Un pilota ritorna* and *L'uomo dalla croce*.

1945

In the midst of post-war chaos Rossellini makes *Roma città aperta,* which is not well received in Italy, but causes a sensation in France and the USA. Employing a rough, semi-documentary style – improvisation and the use of amateur actors – Rossellini enters new cinematographic territory and inaugurates the epoch of "Italian neo-realism". With *Paisàn* and *Germania anno zero* Rossellini enhances his international fame.

1946

Travels to the USA, together with Anna Magnani, with whom Rossellini has been involved ever since the dissolution of his marriage. The movie producer David Selznick offers Rossellini the chance to make seven movies in Hollywood, but does not receive an answer.

1949

Hollywood star Ingrid Bergman openly declares her admiration for Rossellini. The Bergman-Rossellini love affair turns into a scandal raked over constantly by the gutter press. In 1950 they marry and have three children: Roberto Jr. (1950), Isabella and Isotta Ingrid (1952).

Starting with *Stromboli* they make six movies together – *Europa '51, Siamo donne, Viaggio in Italia, Giovanna d'Arco al rogo, La paura* – which are more or less without commercial success and are criticized by admirers of Rossellini's previous work as personal escapades and a betrayal of his neo-realist principles.

Young film-makers of the *Nouvelle Vague* – Truffaut, Godard, Rivette, Rohmer – however, see in these films their shining examples.

1957

Travels to India as a reaction to the lack of success of his works and projects. Two films – *J'ai fait un beau voyage* and *India, Matri Buhmi* – and again a scandal: separates from Ingrid Bergman and falls in love with Sonali DasGupta. He adopts her son Gil (1956). They have a daughter Raffaella (1958).

1959

Surprising success of *Il generale Della Rovere,* which is not repeated with *Era notte a Roma.*

In the 60s and 70s Rossellini largely withdraws from commercial movie-making and takes up television projects, which aim filling a grand canvas with the portrayal of western civilization: portraits of leading personalities – *Sokrates, Augustinus, Descartes, Blaise Pascal* – and chronicles of important epochs: *The Iron Age, The History of the Apostles, The Era of Cosimo de Medici.*

All these films are generally derided as dry educational material. Very few critics applaud the "incomparable encyclopedic genius of Rossellini" and praise *La prise du pouvoir par Louis XIV* (1966) or *Blaise Pascal* (1971).

1973

Separation from Sonali. He falls in love and lives with script writer Silvia D'Amico.

1977

President of the jury at the Cannes Film Festival. Plans his next television projects: *Diderot, Caligula, La rivoluzione industriale, La rivoluzione americana, Lavorare per l'umanità* (about Karl Marx and Friedrich Engels). Dies on 3 June in Rome.

1987

"Tutto Rossellini": extensive retrospective accompanied by numerous lectures at the film festival in Pesaro. Rossellini is honoured for all aspects of his work – as co-founder of Italian neo-realism, as the inspiration of the *Nouvelle Vague* and as the "great encyclopedist of the movies".

2006

For Rossellini's centennial of his birth numerous retrospectives are planned. Most notably the Cinémathèque Française, British Film Archive, Ontario Cinémathèque and MOMA Museum of Modern Art, New York.

Most of Rossellini's papers are collected at the ROBERTO ROSSELLINI FOUNDATION and the CENTRO SPERIMENTALE in Rome. More papers are with the Ingrid Bergman Archive at WESLEYAN UNIVERSITY in Middletown, Connecticut, USA.

CINECITTÀ HOLDINGS is in the process of restoring most of Rossellini's films and controls most of the distribution rights.

Filmography

1937

Prélude à l'après-midi d'un faune (short film)
Directed by: Roberto Rossellini
Playful nature documentary, inspired by Claude Debussy's music.

1939

Fantasia sottomarina (short film)
Directed by: Roberto Rossellini – Director of Photography: Rodolfo Lombardi – Music: Edoardo Micucci
Ten-minute documentary about fishes.

Il tacchino prepotente (short film)
Directed by: Roberto Rossellini – Director of Photography: Mario Bava

La vispa Teresa (short film)
Directed by: Roberto Rossellini – Director of Photography: Mario Bava

1941

Il ruscello di Ripasottile (short film)
Directed by: Roberto Rossellini – Director of Photography: Rodolfo Lombardi – Music: Umberto Mancini

La nave bianca
Directed by: Roberto Rossellini – Idea & Supervision: Francesco De Robertis – Written by: Roberto Rossellini, Franceso De Robertis – Director of Photography: Giuseppe Caracciolo – Music: Renzo Rossellini – Art Director: Amleto Sonetti – Sound: Piero Cavazzuti – Editor: Eraldo Da Roma – Produced by: Scalera Film in association with the navy – Country of Origin: Italy – Length: 77'
Filmed with amateur actors, German and Italian soldiers, on board the hospital ship *Arno* on location in Taranto harbour. Just like *Un pilota ritorna* part of a series of propaganda movies.

1942

Un pilota ritorna

Directed by: Roberto Rossellini – Idea & Supervision: Vittorio Mussolini – Written by: Roberto Rossellini, Michelangelo Antonioni, Massimo Mida – Director of Photography: Vincenzo Seratrice – Music: Renzo Rossellini – Sound: Franco Robecchi – Editor: Eraldo Da Roma – Cast: Massimo Girotti (Lieutnant Gino Rossati), Michela Belmonte (Anna), Gaetano Maser (Lieutnant Trisotti), Officers of the Italian air force – Produced by: Anonima Cinematografica Italiana – Country of Origin: Italy – Length: 88'

Dedication: "This film is dedicated with brotherly affection to the pilots who did not return from the skies above Greece."

1943

L'uomo dalla croce

Directed by: Roberto Rossellini – Idea & Supervision: Asvero Gravelli – Written by: Roberto Rossellini, Asvero Gravelli, Alberto Consiglio – Director of Photography: Guglielmo Lombardi, Aurelio Attili – Music: Renzo Rossellini – Cast: Alberto Gavazzi (military chaplin), Roswita Schmidt (Irina), Attilio Dottesio, Aldo Capacci, Doris Hild – Produced by: Continentalcine – Country of origin: Italy – Length: 88'

The story is based on the life of the military chaplin Reginaldo Giuliani, who fell on the Russian front.

1943/44

Desiderio

Directed by: Roberto Rossellini, Marcello Pagliero – Written by: Rosario Leone, Giuseppe De Santis, Roberto Rossellini, Diego Calcagno – Director of Photography: Rodolfo and Ugo Lombardi – Music: Renzo Rossellini – Cast: Elli Parvo (Paola Previtali), Massimo Girotti (Nando Selvini), Carlo Nichi (Giovanni Mirelli)

Rossellini started filming in 1943, but had to interrupt the work because of the war. Marcello Pagliero, who in *Roma, città aperta* plays the engineer Manfredi, finished the movie in 1945. There is a definite difference between *Desiderio* and the three previous war movies: the distance between the camera and the actors (literally and figuratively speaking). Rossellini began to be interested in people.

1945

Roma, città aperta

Directed by: Roberto Rossellini – Written by: Roberto Rossellini, Sergio Amidei, Federico Fellini – Director of Photography: Umberto Arata – Music: Renzo Rossellini – Editor: Eraldo Da Roma – Sound: Raffaele Del Monte – Cast: Aldo Fabrizi (Don Pietro Pellegrini), Anna Magnani (Pina), Marcello Pagliero (Ingenieur Giorgio Manfredi), Harry Feist

(Major Bergmann), Maria Michi (Marina), Giovanna Galetti (Ingrid) – Produced by: Excelsa Film – Country of Origin: Italy – Length: 100'

It was meant to be a documentary of the priest, Don Morosini, who had been shot by the Nazis, but turned out to be the birth of "Italian neo-realism" inspired by the resistance movement. "The film", according to Godard, "gave Italy back her dignity and identity."

1946

Paisàn

Directed by: Roberto Rossellini – Concept: Roberto Rossellini, Sergio Amidei, Federico Fellini, Victor Hayes, Klaus Mann, Marcello Pagliero – Written by: Roberto Rossellini, Sergio Amidi, Federico Fellini, Vasco Pratolini – Director of Photography: Otello Martelli – Music: Renzo Rossellini – Editor: Eraldo Da Roma – Cast: Sicilian episode: Carmela Sazio (Carmela), Robert Van Loon, Benjamin Emanuel (American soldier), Harald Wagner, Albert Heinze (German soldiers); Neapolitan episode: Dots Johnson (Joe), Alfonsino Pasca (Pasquale, boy); Roman episode: Gar Moore (Fred), Maria Michi (Francesca); Florentine episode: Harriet White (nurse), Renzo Avanzo, Gigi Gori (partisans), Giulietta Masina (tenant); episode in the monastry: William Tubbs, Newell Jones, Elmer Feldman (military chaplins), monks of the Franciscan monastry of Maiori; episode in the Po-Delta: Dale Edmonds, Cigolani (Partisans) – Produced by: Mario Conti, Rod Geiger, Roberto Rossellini for Organizzazione Film Internazionali and Foreign Film Production – Length: 128'

Allied landing and liberation of Italy described in six episodes. The historical moment is reflected in very ordinary day-to-day occurrences: tragic and comic, melodramatic and tongue-in-cheek. Bazin: "Rossellini's realism has nothing to do with realism in movie-making so far. It's not the realism of topic, but of style."

Germania anno zero

Directed by: Roberto Rossellini – Written by: Roberto Rossellini, Carlo Lizzani, Max Colpet – Director of Photography: Robert Juillard – Editor: Eraldo Da Roma – Sound: Kurt Doubrawsky – Music: Renzo Rossellini – Cast: Edmund Meschke (Edmund Köhler), Ernst Pittschau (Edmund's father), Ingetraut Hinze (Edmund's sister), Franz Gruger (Edmund's brother) , Graf Franz Treuberg (General von Laubniz) – Produced by: Tevere Film – Country of Origin: Italy – Length: 78'

"This movie is dedicated to the memory of my son, Romano." Rossellini's third film, which explores the immediate past. This time Berlin is the location, the time is 1945: ruins, black market and poisoned souls. It tells the tragic story of the 12-year-old Edmund, still haunted by the slogans of the Aryan race ideology.

L'amore

1st story: Una voce umana

Directed by: Roberto Rossellini – Written by: Roberto Rossellini, after a one-act play by Jean Cocteau La voix humaine *– Director of Photography: Robert Juillard – Editor: Eraldo Da Roma – Sound: Kurt Doubrawsky – Music: Renzo Rossellini – Leading Actress: Anna Magnani*

2nd story: Il miracolo

Directed by: Roberto Rossellini – Assistant Director: Federico Fellini – Written by: Tullio Pinelli, Federico Fellini, after a novella Flor de Santidad *by Ramon Del Valle-Inclan – Director of Photography: Aldo Tonti – Editor: Eraldo Da Roma – Sound: Kurt Doubrawsky – Music: Renzo Rossellini – Cast: Anna Magnani (Nannina, shepherdess), Federico Fellini (vagabond) – Produced by: Tevere Film – Country of Origin: Italy – Length: 78'*

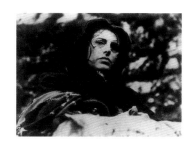

Anna Magnani brilliantly stars in two stories about the disowning of a loving woman. Rohmer: "It is a topic, which all Rossellini's movies have in common: the idea of physical and moral loneliness."

La macchina ammazzacattivi

Directed by: Roberto Rossellini – Concept: Eduardo De Filippo, Filippo Sarazani – Written by: Roberto Rossellini, Sergio Amidei, Franco Busati – Director of Photography: Tino Santoni, Enrico Berutti – Schnitt: Jolanda Benvenuti – Sound: Mario Amari – Music: Renzo Rossellini – Cast: Genaro Pisano (Celestino, photografer), Marilyn Buferd (young American), William and Helen Tubbs (her parents), Giovanni Amato (mayor) – Produced by: Universalia/Tevere Film – Country of Origin: Italy – Length: 83'

Excursion into the comedy genre, with saints, who turn out to be devils, and a camera as a "machine, which kills evil".

1950

Stromboli – Terra di Dio

Directed by: Roberto Rossellini – Written by: Roberto Rossellini, Art Cohen, Sergio Amidei, Gian Paolo Callegari – Director of Photography: Otello Martelli – Editor: Jolanda Benvenuti – Sound: Terry Kellum, Eraldo Giordani – Music: Renzo Rossellini – Cast: Ingrid Bergman (Karin Bjorsen), Mario Vitale (Antonio), inhabitants of the island of Stromboli – Produced by: RKO/Berit-Film – Country of Origin: Italy / USA – Length: 105'

Ingrid Bergman without the aura of the Hollywood diva playing a "displaced person" on a volcanic island.

Francesco, giullare di Dio
Directed by: Roberto Rossellini – Written by: Roberto Rossellini, Federico Fellini, after the legend of St Francis of Assisi I Fioretti di San Francesco and Vita di Fra' Ginepro – Director of Photography: Otello Martelli – Editor: Jolanda Benvenuti – Sound: Eraldo Giordani – Music: Renzo Rossellini – Cast: Aldo Fabrizi (tyrant Nicolaio), Arabella Lemaitre (Santa Chiara), Franciscan monks from the monastry of Maiori – Produced by: Cineriz – Country of Origin: Italy – Length: 75'
Saint Francis portrait as God's storyteller and fool.

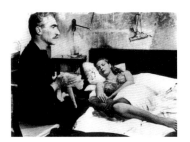

1952

I sette peccati capitali (seven episodes, different directors)
L'Invidia, fifth episode – Directed by: Roberto Rossellini – Written by: Roberto Rossellini, Diego Fabbri, after the novel La Chatte by Colette – Director of Photography: Enzo Serafin – Editor: Louisette Hautecoeur – Music: Yves Baudrier – Cast: Orfeo Tamburi (Orfèo), Anurée Débar (Camilla) – Produced by: Film Constellazione (Rome)/Franco-London (Paris) – Country of Origin: Italy/France – Length of the episode: 20'
Of the seven deadly sins Rossellini chose "envy" and made the murderous jealousy of a cat seem the most matter-of-fact occurence in the world.

Europa 51
Directed by: Roberto Rossellini – Written by: Roberto Rossellini, Sandro De Feo, Antonio Pietrangeli, Massimo Mida, Antonello Trombadori – Director of Photography: Aldo Tonti – Editor: Jolanda Benvenuti – Sound: Piero Cavazzuti, Paolo Uccello – Music: Renzo Rossellini – Cast: Ingrid Bergman (Irene Girard), Alexander Knox (her husband George), Sandro Franchina (her son Michel), Giulietta Masina (Giulietta), Teresa Pellati (Ines), Antonio Pietrangeli (psychiatrist) – Produced by: Ponti-De Laurentiis – Country of Origin: Italy – Length: 110'
Ingrid Bergman as a grieving mother, whose desire to do good lands her in an asylum.

Dov'è la libertà…?
Directed by: Roberto Rossellini – Written by: Roberto Rossellini, Vitaliano Brancati, Ennio Flaiano, Antonio Pietrangeli, Vincenzo Malarico – Director of Photography: Aldo Tonti, Tonio Delli Colli – Editor: Jolanda Benvenuti – Sound: Paolo Uccello – Music: Renzo Rossellini – Cast: Totò (Salvatore), Leopoldo Tristo (Abramo), Vera Molnar (Agnesina), Produced by: Ponti-De Laurentiis/Golden Films – Country of Origin: Italy – Length: 95'
Splendid role for the clown Totò: a prisoner, released early, finds the world outside so disgusting and mad, that he wants to go back to prison.

1953

Viaggio in Italia

Directed by: Roberto Rossellini – Written by: Roberto Rossellini, Vitaliano Brancati – Director of Photography: Enzo Serafin – Editor: Jolanda Benvenuti – Sound: Eraldo Giordani – Music: Renzo Rossellini – Cast: Ingrid Bergman (Katherine Joyce), George Sanders (Alexander Joyce), Paul Muller (Paul Dupont) – Produced by: Sveva Film/Junior Film/Italia Film – Country of Origin: Italy – Length: 75'

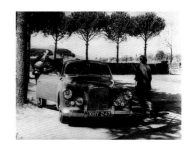

Ingrid Bergman and George Sanders play a British couple, who travel through Italy to Naples while going through a relationship crisis: estrangement, separation and reconciliation. Rossellini: "This is a film I love very much. It was important for me to show Italy, Naples, its strange atmosphere, which includes this real, deep feeling: this feeling of eternal life."

Siamo donne (several episodes, different directors)
Ingrid Bergman, third episode

Directed by: Roberto Rossellini – Written by: Cesare Zavattini, Luigi Chiarini – Director of Photography: Otello Martelli – Editor: Jolanda Benvenuti – Sound: Giorgio Pallotta – Music: Allesandro Cicognini – Cast: Ingrid Bergman (plays herself), also appearing: Robertino, Isotta and Isabella Rossellini – Produced by: Titanus/Costellazione/Guarini – Country of Origin: Italy – Length of the episode: 20'

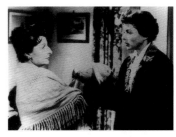

Ingrid Bergman chases away a cockerel, who is destroying the rose bushes in her garden.

Amori di mezzo secolo (several episodes, different directors)
Napoli 1943, fourth episode

Directed by: Roberto Rossellini – Written by: Roberto Rossellini, Oreste Biancoli, Vinicio Marinucci – Director of Photography: Tonino Delli Colli – Editor: Jolanda Benvenuti – Music: Carlo Rusticelli – Cast: Antonella Lualdi (Carla), Franco Pastorino (Renato) – Produced by: Excelsa/Roma – Country of Origin: Italy – Length of the episode: 15'

1954

Giovanna d' Arco al rogo (Film of the theatre production)

Directed by: Roberto Rossellini – Written by: Roberto Rossellini, after the play Jeanne au bucher by Paul Claudel and Arthur Honegger – Director of Photography: Gabor Pogany – Editor: Jolanda Benvenuti – Sound: Paolo Uccello – Cast: Ingrid Bergman (Jeanne d' Arc), Tullio Carminati (Brother Domenico), Giancinto Prandelli (Porcus) – Singer: Marcella Pobbe, Giancinto Prandelli, Florence Quartararo – Produced by: Produzioni Cinematografiche Associate – Country of Origin: Italy /France – Length: 80'

Recording of a theatre production of Paul Claudel's Oratorio at the Teatro San

Carlo in Naples, starring Ingrid Bergman. "I wanted to record a production, which I felt passionately enthusiastic about," Rossellini said. "I had no experience with theatre productions - everything was new, everything had to be discovered."

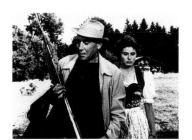

La paura – Non credo più all'amore
Directed by: Roberto Rossellini – Written by: Roberto Rossellini, Sergio Amidei, Franz Treuberg, after Stefan Zweig's story Die Angst *– Director of Photography: Carlo Carlini, Heinz Schackertz – Editor: Jolanda Benvenuti, Walter Boos – Sound: Carl Becker – Music: Renzo Rossellini – Cast: Ingrid Bergman (Irene Wagner), Mathias Wiemann (her husband), Kurt Kreuger (Lover), Renate Mannhardt (blackmailer), short appearance by Klaus Kinski – Produced by: Ariston/Aniene – Country of Origin: Italy/Federal Republic of Germany – Length: 81'*
Last Rossellini-Bergman cooperation.

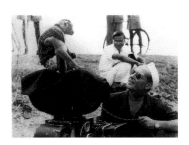

1957–58

J'ai fait un beau voyage (television documentary)
Directed & Written by: Roberto Rossellini – Cameraman: Aldo Tonti
Ten-part television series, each part being between 21 and 28 minutes long, commissioned by the French broadcaster ORTF. The Italian RAI aired the series under the title *L'India vista da Rossellini*.

1959

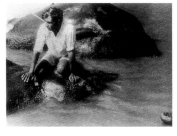

India, Matri Buhmi
Directed by: Roberto Rossellini – Assistant Directors: Jean Herman, Tinto Brass – Written by: Roberto Rossellini, Sonali DasGupta, Fareydoun Hoveyda – Director of Photography: Aldo Tonti – Music: Philippe Arthuis – Cast of amateur actors – Produced by: Aniene (Rome)/UGC (Paris) – Country of Origin: Italy/France – Length: 90'
Truffaut: "In its simplicity and intelligence this is an extraordinary film, which conveys a global view of the world and is a meditation on life, nature and animals."

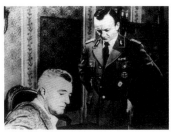

Il generale Della Rovere
Directed by: Roberto Rossellini – Written by: Indro Montanelli, Sergio Amidei, Diego Fabbri – Director of Photography: Carlo Carlini – Editor: Cesare Lavagna – Sound: Ovidio Del Grande – Music: Renzo Rossellini – Cast: Vittorio De Sica (Emanuele, con man), Hannes Messemer (Oberst Müller); Sandra Milo (Olga), Anne Vernon (widow Carla), Herbert Fischer, Kurt Selge – Produced by: Zebra (Rome)/Gaumont (Paris) – Country of Origin: Italy/France – Length: 132'
Genoa under German occupation during the winter of 1943. Vittorio De Sica starrs as the con man turned hero.

1960

Era notte a Roma

Directed by: Roberto Rossellini – Written by: Roberto Rossellini, Sergio Amidei, Diego Fabbri, Brunello Rondi – Director of Photography: Carlo Carlini – Editor: Roberto Cinquini – Sound: Enzo Magli – Music: Renzo Rossellini – Cast: Leo Glen (Major Michael Pemberton), Giovanna Ralli (Esperia), Sergej Bondartschuk (Sergeant Nazukov), Peter Baldwin (Lieutnant Bradley), Hannes Messemer (Oberst Baron von Kleist), Laura Betti (friend of Esperia) – Produced by: Golden Star (Geneva)/Dismage (Paris) – Country of Origin: Italy – Length: 120'

Once again: winter 1943. In Rome the German soldiers have changed from being allies into occupiers. Three prisoners of war – a Briton, an American and a Russian – manage to escape and have to stay hidden until the arrival of the allies.

Viva l'Italia

Directed by: Roberto Rossellini – Written by: Roberto Rossellini, Sergio Amidei, Diego Fabbri, Antonio Petrucci, Antonello Trombadori – Director of Photography: Luciano Trasatti – Editor: Roberto Cinquini – Sound: Enzo Magli, Oscar Di Santo – Music: Renzo Rossellini – Cast: Renzo Ricci (Giuseppe Garibaldi), Paolo Stoppa (Nino), Franco Interlenghi (Giuseppe Bandi), Giovanna Ralli (Rosa), Raimondo Croce (Francesco II) – Produced by: Cineriz/Tempo/Galatea (Rome)/Francinex (Paris) – Country of Origin: Italy/France – Length: 128'

Chronicle of the unification of Italy by Giuseppe Garibaldi. Pathos-free portrait of a national hero. Rossellini: "I know what I want to say and I use the directest way of doing so. It is enough to have clear thoughts and concepts in order to be able to find the directest images to express that idea."

1961

Vanina Vanini

Directed by: Roberto Rossellini – Written by: Roberto Rossellini, Diego Fabbri, Jean Gruault, Monique Lange, Antonello Trombadori, after Stendhal's novel Vanina Vanini *– Director of Photography: Luciano Trasatti – Editor: Daniele Alabiso – Sound: Oscar De Angelis – Music: Renzo Rossellini – Cast: Sandra Milo (Princess Vanini), Laurent Terzieff (Pietro), Paolo Stoppa (Prince Vanini), Martine Carol (Contessa Vitelleschi), Jean Gruault (messenger) – Produced by: Zebra Film (Rome)/Orsay Film (Paris) – Country of Origin: Italy/France – Length: 125'*

Tragic love story of Princess Vanina Vanini, who falls in love with the young freedom fighter Pietro Missirille, who fights the society she represents.

Torino nei cent'anni/Torino tra due secoli
Directed by: Roberto Rossellini – Written by: Valentino Orsini – Director of Photography:
Leopoldo Piccinelli, Mario Vulpiani, Mario Volpi – Editor: Vasco Micucci – Historical
Advisor: Carlo Casalegno, Enrico Gianeri – Commentary: Vittorio Gorresio
These are documentaries on the history of Turin commissioned by Italian television.

1962

Anima nera
Directed by: Roberto Rossellini – Written by: Roberto Rossellini, Giuseppe Griffi, Alfio Val-
darnini – Director of Photography: Luciano Trasatti – Editor: Daniele Alabiso – Music:
Piero Piccione – Cast: Vittorio Gassmann (Adriano), Annette Stroyberg (Marcella), Nadja
Tiller (Mimosa) – Produced by: Documento Film (Rome)/Le Louvre Film (Paris) –
Country of Origin: Italy/France – Length: 98'

Vittorio Gassmann as Halodri, who can't find redemption. Rossellini shows that
he can tell stories in the same modern, relaxed and merciless way as the young
authors of the *nouvelle vague* and draws one of the most sinister male figures of
his career.

1963

Rogopag – Lavamoci il cervello (several episodes, different directors)

Illibatezza, first episode
Directed & Written by: Roberto Rossellini – Director of Photography: Luciano Trasatti –
Editor: Daniele Alabiso – Music: Carlo Rusticelli – Cast: Rosanna Schiaffino (Stewardess
Anna Maria), Bruce Balaban (Joe, advertising executive), Gianrico Tedeschi (psychiatrist)
– Produced by: Arco Film (Rome)/Lyre Film (Paris) – Country of Origin: Italien/Frank-
reich – Length of episode: 33'

Fifty-year-old American advertising executive obsessed with sex. The other epi-
sodes are directed by Jean-Luc Godard, Pier Paolo Pasolini, Ugo Gregoretti.

1964

L'Età del ferro (television series)
Directed, Written & Narrated by: Roberto Rossellini – cameraman: Carlo Carlini –
Editor: Daniele Alabiso – Music: Carmine Rizzo – Produced by: RAI/Istituto Luce Arco
Film – Country of Origin: Italy – Length: 266'
Five-part television documentary about the age of iron: from the discovery of
iron to the mass-production of cars.

1966

La prise du pouvoir par Louis XIV *(television drama)*
*Directed by: Roberto Rossellini – Written by: Philippe Erlanger, Jean Gruault –
cameraman: Georges Leclerc – Editor: Armand Ridel – Sound: Jacques Gayet – Cast:
Jean-Marie Patte (Lluis XIV), Raymond Jourdan (Colbert), Giulio Silvani (Mazarin),
Katharina Renn (Anne of Austria), Pierre Barat (Fouquet) – Produced by: ORTF –
Country of Origin: France – Length: 120'*
How the Sun King occupies his enemies with questions of court dress and thereby brings all the instruments of the state under his control.

1967–1969

La lotta dell'uomo per la sua sopravvivenza *(television series)*
*Conceived and Written by: Roberto Rossellini – Directed by: Renzo Rossellini jr. – Produced by: RAI/Orizzonte 2000 (Rome)/Logos Film (Paris)/Romania Film (Bucharest) –
Country of Origin: Italy/France/Romania – Length: 10 hr 47 min.*
12-part series about man's battle for survival

1968

Atti degli apostoli *(television series)*
*Directed by: Roberto Rossellini – Written by: Roberto Rossellini, Jean-Dominique de La
Rochefoucauld, Luciano Scaffa, Vittorio Bonicelli, after the history of the apostles from the
New Testament – Director of Photography: Mario Fioretti – Editor: Jolanda Benvenuti –
Music: Mario Nascimbene – Cast: Edoardo Torricella (Paul), Jacques Dumur (Peter), Renzo Rossi (Zacharias), Bradai Ridha (Matthew) – Produced by: Orrizonte 2000 for
RAI/ORTF/Studio Hamburg/TVE – Length: 5 hr 42 min*

The travels and the story of the 12 apostles after Jesus' Ascension. Rossellini: "My sources, my education is Christian, but I am not a practicing Christian. And in this case it doesn't matter whether one is a Christian or not. The question is much simpler: does one trust people or not!"

1970

Socrate *(television drama)*
*Directed by: Roberto Rossellini – Written by: Roberto Rossellini, Maria Bornigia, Marcella
Mariani, Jean-Dominique de La Rochefoucauld, after Plato's* Dialogues *– cameraman:
Jorge Martin – Editor: Alfredo Muschietti – Music: Mario Nascimbene – Cast: Jean Sylvère (Socrates), Anne Caprile (Xanthippe), Ricardo Palacios (Kriton), Beppy Mannaiuolo
(Appolodorus) – Produced by: Orrizonte 2000 for RAI/ORTF/TVE – Country of Origin:
Italy/France/Spain – Length: 120'.*

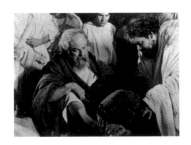

Begins with the Spartans conquering Athens in 404 BC. Ends with Socrates's suicide and a long meditation on death. Godard: "Socrates is like Rossellini. He was poisoned because he asked questions. He accepted all. He just wanted to talk to people."

1971

Intervista a Salvador Allende (television documentary)
Directed by: Roberto Rossellini, Emilio Greco
Interview with the Chilean President Salvador Allende, broadcast by Italian television with the title *La forza e la ragione*.

Blaise Pascal (television drama)
Directed by: Roberto Rossellini – Written by: Roberto Rossellini, Marcella Mariani, Jean-Dominique de La Rochefoucauld, Luciano Scaffa – Cameraman: Mario Fioretti – Editor: Jolanda Benvenuti – Music: Mario Nascimbene – Cast: Pierre Arditi (Blaise Pascal), Rita Forzano (Jacqueline Pascal), Giuseppe Addobbati (Etienne Pascal), Christian De Sica (Leutnant) – Produced by: Orrizonte 2000 for RAI/ORTF – Country of Origin: Italy/France – Length: 131'

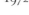

Blaise Pascal (1632–1682) was a scientist, philosopher and a religious dissenter, who wrote his central insight on a piece of paper and sewed it into his jacket: "Fire, God of Abraham, Issaac and Jacob, but not of the philosophers and the sages."

1972

Agostino d'Ippona (television drama)
Directed by: Roberto Rossellini – Written by: Roberto Rossellini, Marcella Mariani, Jean-Dominique de La Rochefoucauld, Luciano Scaffa – Cameraman: Mario Fioretti – Editor: Jolanda Benvenuti – Music: Mario Nascimbene – Cast: Dary Berkany (Augustine), Virginio Gazzolo (Alipio), Cesare Barbetti (Volusiano) – Produced by: Orrizonte 2000 for RAI – Country of Origin: Italy – Length: 121'

The scholar of rhetoric and theologian Augustine is named bishop of Hippo. Rossellini: "I would never make a movie about Pascal or Descartes or Augustine or another figure, because I like him. It doesn't matter to me, whether I like him or not. I choose my subjects on the basis of whether they contribute to the understanding of a process."

L'Età di Cosimo de Medici (television drama)

Directed by: Roberto Rossellini – Written by: Roberto Rossellini, Marcella Mariani, Luciano Scaffa – Cameraman: Mario Montuori – Editor: Jolanda Benvenuti – Music: Manuel De Sica – Cast: Marcello Di Falco (Cosimo de Medici), Virginio Gazzolo (Leon Battista Alberti), Mario Erpichini (Totto Machiavelli) – Produced by: Orrizonte 2000 for RAI – Country of Origin: Italy – Length: 250'

Three parts: Cosimo de Medici in exile; Cosimo at the height of his power in Florence; the universal genius Leon Battista Alberti explains his scientific research and his architectural projects.

1973

Cartesius (television drama)

Directed by: Roberto Rossellini – Written by: Roberto Rossellini, Marcella Mariani, Luciano Scaffa – Cameraman: Mario Montuori – Editor: Jolanda Benvenuti – Music: Mario Nascimbene – Cast: Ugo Cardea (René Descartes), Anne Pouchie (Elena), Claude Berthy (Guez de Balzac) – Produced by: Orrizonte 2000 for RAI/ORTF – Country of Origin: Italy/France – Length: 150'

René Descartes portrayed as a thinker, who anticipates modernity.

1974

Anno uno

Directed by: Roberto Rossellini – Directed by: Roberto Rossellini, Marcella Mariani, Luciano Scaffa – Director of Photography: Mario Montuori – Editor: Jolanda Benvenuti – Music: Mario Nascimbene – Cast: Luigi Vanucchi (Alcide De Gasperi), Dominique Darel (Romana De Gasperi), Valeria Sabel (Francesca De Gasperi), Tino Bianchi (Togliatti) – Produced by: Rusconi Film – Country of Origin: Italy – Length: 125'

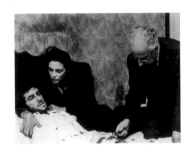

Alcide De Gaspari, a high official of the Italian conservative party, the *Democrazia Cristiana*, is named foreign minister and then prime minister of Italy at the very end of World War II.

The World Population (documentary)

Concept and Commentary: Roberto Rossellini – Directed by: Renzo Rossellini jr. – Length: 120'

1975

Il Messia

Directed by: Roberto Rossellini – Written by: Roberto Rossellini, Silvia D'Amico Benedico – Director of Photography: Mario Montuori – Editor: Jolanda Benvenuti, Laurent Quaglio – Music: Mario Nascimbene – Cast: Pier Maria Rossi (Jesus), Mita Ungaro (Maria), Carlos de Carvalho (John the Baptist), Jean Martin (Pontius Pilate) – Produced by: Orrizonte 2000 (Rome)/Telefilm Produktion (Paris) – Country of Origin: Italy/France – Length: 145'

The story of Christ as recounted in the four Gospels. Told in the style of a sober, strictly historical documentary.

1977

Concerto per Michelangelo (documentary)

Directed by: Roberto Rossellini – Director of Photography: Mario Montuori – Produced by: RAI – Length: 60'

Hommage to Michelangelo: a concert by the Vatican Orchestra is recorded for television.

Beaubourg, centre d'art et de culture Georges Pompidou (documentary)

Directed by: Roberto Rossellini – Director of Photography: Nestor Almendros – Editor: Véritable Silve, Dominique Taysse – Produced by: Information-Film Jacques Grandclaude (Paris) – Length: 57'

Film about the opening of the Centre Pompidou, which is mainly concerned with the architecture of the building.

Appendix compiled by Rainer Gansera.

"Now we are alone in the woods."

Telegram from Jean-Luc Godard to us children
on the occasion of our father's death, June 1977.

"To Iso. Your father's chair. Davidino – David Lynch, 1991"
My father's favorite chair in the Hotel Raphaël in Paris.
Photo: David Lynch.

Text Credits

All texts not listed here are written for this edition by the author.

pp 11–15 *About My Family,* from: Isabella Rossellini, *Some of Me,* Schirmer/Mosel Verlag, Munich 1997 (this chapter has been edited and amended by the author for this edition).

pp 17–20 *About My Father,* from: Isabella Rossellini, *Some of Me,* from: Isabella Rossellini, *Some of Me,* Schirmer/Mosel Verlag, Munich 1997

pp 27–28 *Movie Making with Isabella. By Guy Maddin.* Contribution by the Canadian director Guy Maddin on the occasion of the première of *My Dad is 100 Years Old* at the International Toronto Film Festival in September 2005. © Guy Maddin

pp 75ff. *How Everything Began: Letters and Memories.*

pp 75–79, pp 88–99 from: *Ingrid Bergman. My Story,* Delacorte Press, New York 1980 © Estate of Ingrid Bergman

pp 83–87 *Roberto Rossellini: How I Saw It,* from: *Dix ans de cinéma. Roberto Rossellini.* Cahiers de Cinéma, Paris 1955 Translated from the French by Nathalie Villemur. © Cahiers du Cinéma

pp 102–104 *Roberto Rossellini about his work,* from: Stefano Roncoroni, *Roberto Rossellini. Quasi un autobiografia,* Arnoldo Mondadori Editore, Mailand 1987. Translated from the Italian by Guido Waldman.

pp 107–109 Letter from Roberto Rossellini to his children of 17 January 1957 © Wesleyan University Cinema Archives. Translated from the Italian by Guido Waldman.

pp 113–115 Memories of Federico Fellini, from: Charlotte Chandler, *I, Fellini,* Random House, New York 1995 © Charlotte Chandler, New York

pp 117–124 François Truffaut/Eric Rohmer, *How did you do that, Signor Rossellini?* Abbreviated edition of an interview published by *Cahiers du Cinéma,* No 37, July 1954, pp 1–12. Translated from the Italian by Guido Waldman. © Cahiers du Cinéma